Classic
SCRAPBOOKING

Classic SCRAPBOOKING

by

Vera Rosenbluth &
Susan McDiarmid

Hartley & Marks
PUBLISHERS

Published by

HARTLEY & MARKS PUBLISHERS INC.

Post Office Box 147 3661 W. Broadway
Pt. Roberts, WA Vancouver, BC
98281 V6R 2B8

Printed in the U.S.A.

Text illustrations by Susan McDiarmid
Cover design by Diane McIntosh

ISBN 0-88179-163-6

LIBRARY OF CONGRESS CATALOGING-IN-PUBLICATION DATA

Rosenbluth, Vera, 1946–
 Classic scrapbooking / by Vera Rosenbluth & Susan McDiarmid.
 p. cm.
 Includes index.
 ISBN 0-88179-163-6
 1. Photograph albums. 2. Photographs—Conservation and
restoration. 3. scrapbooks. 4. Souvenirs (Keepsakes)
 1. McDiarmid, Susan, 1969– II. Title.
TR465.R67 1998
745.593—dc21 98-40792
 CIP

Chapters

Projects

Notes

Acknowledgments

Firstly, my gratitude to the following people who generously shared their thoughts and scrapbooks with me:

Anita Boonstra, Violet Burgess, Elizabeth Campbell, Debbie and Duncan Clelland, Barbara and Alleyne Cook, Reesa Margolis Devlin, Christena Docherty, Betty Dwyer, Doramy Ehling, Patricia Evans, Joan Fisher, Sandy Goodall, Maetel Grant, Melanie, Elyse and Evan Henderson, Evelyn Horton, Kerry Howard, Peggy Jessome, Sara Jewell, Dagmar Kaffanke-Nunn, Linda Lines, Robert McDiarmid, Darlene Meyers-Jackson, Victoria Miles, Sandra Moe, Don Mowatt, Nancy Pollak, Judi Porter, Mimi Rondenet-White, Maxine Shaw, Barbara Shumiatcher, Lynn Smith, Cassandra Smythe, Bill Terry, Marie Van Barneveld, Adam Waldie, Lorraine Waring, Richard Wilcox, Erin Wild;

also to Bill Richardson and Marke Andrews for their support;

to Ann, Susan, Marla and the rest of the Douglas Park dog owners for their interest;

to editor Susan Juby, for pleasant working sessions over cups of coffee at Angus Cafe, and to Vic Marks and his staff for caring how a book looks and feels as well as what is in it;

especially and always to Robin, Jonathan and Marc for making it all worthwhile.

—Vera Rosenbluth

I would like to thank all of the people who lent us their scrapbooks to pore over and be inspired by. In particular I would like to thank:

Peggy Jessome for making books whose design and composition truly bring new meaning to the term classic scrapbook;

Susanna Gilbert for her generous advice and loan of resources as well as book-making talents;

Ailsa Aitken, Tammy Brown, Ann Grant, Jill Pelletier from the Scrapbook Warehouse, and Sophie Rolland.

Thank you also to Vic Marks and Supriti Bharma for encouragement, Glenda Wilshire for her eagle eye, John McKercher and The Typeworks for excellent typesetting and Diane McIntosh for a lovely design, inside and out.

Finally I would like to thank James Waring whose support, companionship, thoughtful opinions, and understanding of my hectic schedule made my contribution to this book possible.

—Susan McDiarmid

Introduction

The growth of interest in scrapbooking in the past few years has been nothing short of phenomenal. Stationery and gift stores as well as increasing numbers of specialty scrapbooking supply stores carry racks of albums, paper, pens, scissors, stickers, stamps, and templates to attract the scrapbook enthusiast. Workshops to teach new techniques in scrapbooking are held in homes, stores, at conventions, and even on special boat cruises. Information about interesting, creative, and novel ways to enhance scrapbook pages is passed through word of mouth, newsletters, magazines, and Internet sites. The scrapbooking hobby business has blossomed from virtually nothing a few years ago into an industry generating $200 million dollars a year — and it continues to grow.

This new wave of scrapbooking is, however, quite different from what I would call classic scrapbooking. Classic scrapbooking, I would suggest, is based primarily on the stories and tangible memories of a lifetime or a particular period of life. Paper memorabilia, and other cherished items that can be pressed in a book, are the hallmarks of classic scrapbooks. As nine-year-old Elyse Henderson told me when I asked her why she kept a journal and a photo album as well as a scrapbook: "The scrapbook is for stuff that you find." In many cases what is currently called "scrapbooking" is actually putting together creative photo albums, using commercially available products. This approach to making a memory album is based more on photographs, and emphasizes presentation, decoration, layout, and design. A great contribution to the world of scrapbooks and creative photo albums has been the awareness of archival preservation using sophisticated methods and materials.

There are many examples of the differences between a classic approach to scrapbooking and the current way of putting together creative photo albums. A wedding album that includes newspaper

notices, an invitation, some handwritten notes about wedding plans and the guest list, the wedding program, the menu, a napkin, pressed flowers from the bridal bouquet, a written description of the wedding day, and some photos is definitely a classic scrapbook. A wedding album that is primarily photographs cropped in different shapes, matted on colored paper, laid out on paper with decorated borders, and surrounded with stickers, stamps, die-cut or punched motifs, and flowers bought in a hobby shop is what I think of as a creative photo album. A classic scrapbook would tell the story of a mountain hike by means of photos plus a few pressed wildflowers, a trail map, a brochure of the birds and plants from the area, and a written description of the day. The story and photos of a child's soapbox race can be accompanied in a scrapbook by the hand-drawn plans for building the vehicle, the newspaper report, and the ribbon the child got for participating. A special meal in a Chinese restaurant can be documented by a photo taken by the waiter as well as the placemat and bill written in Chinese characters.

Memorabilia constitutes an essential element of classic scrapbooks. Objects are concrete reminders of experiences, as well as the emotions and sensory memories that surround those experiences. Photos evoke the visual memories, but a photo accompanied by a physical item saved from the same event recalls the whole experience in a particularly evocative way. One scrapbook I saw, made in the 1940s, contained a beautiful black and white wedding photo accompanied on the same page by a faded blue garter. A photo of a mountain lake was placed beside a small ptarmigan feather, and a newspaper article about the death of an important person was laid out beside a piece of black armband from the funeral. In each case, the objects gave immediacy and a concrete sense of reality to the faded photos and handwritten notations. The objects made the photos more than just misty memories from the past. They brought back the color and feelings of the original experience. The memories on the pages were not overpowered by decorations and layout, and the combination of photos and memorabilia made the stories come to life.

Classic scrapbooking evolved from the time of our grandparents and great-grandparents. One of the most important developments in the modern scrapbooking movement has been the growth in awareness of the importance of archival materials. Acid-free supplies are readily available, and we now know how to ensure that our most valuable books will last for generations. Of course the content as well as the form of scrapbooks is influenced by the age of the scrapbooker, the era in which the book is created, and the materials available. Photos are more common in the scrapbooks of today partly because it was not until the 1950s that photography became an affordable hobby. We don't write as many letters as our parents or grandparents did, so it is not surprising that older scrapbooks contained more memories in the form of notes, party invitations, and letters than do contemporary scrapbooks. Whatever the content of the scrapbook, the intent is to preserve precious memories. The recent surge of interest in scrapbooking indicates an awareness that in our fast-paced lives it is important not to let important experiences and relationships slip away, but to hold on to them and give them concrete form.

What can be said in this book that hasn't already been said elsewhere? My interest lies in the stories behind the artifacts and pictures, the reasons that we keep memorabilia, the real value in making scrapbooks. While writing *Keeping Family Stories Alive: Discovering & Recording the Stories and Reflections of a Lifetime*, I became aware of the myriad ways, including oral history, that individuals and families have always sought to preserve memories. I thought about the scrapbooks many of us kept as children and teenagers and the impulse that leads us to collect those little things that are important to us: the tickets and baggage tags from trips, the programs from music concerts — whether rock or chamber music! — the notes passed between best friends at school, cards and greetings from special occasions. All these things are very personal and individual, and serve as touchstones for memories of a bygone era.

In speaking with scrapbookers of all generations, I gained an appreciation for the diverse reasons that keeping a scrapbook is valu-

able, both for the person who put it together as well as for the people who look at it later. At the same time, I heard about the challenges people face in their busy lives to find the time to scrapbook, a workable method of organization, and the particular format that allows them to achieve a satisfying result.

Scrapbooks can be a way of recording our own experiences or important features of our children's lives, or bringing together documents, pictures, and stories of family history. World events, vacation trips, and collections can all be preserved in a personal scrapbook. Memory albums can be created as school projects, as part of a museum display, or as a memorial to a loved family member who has passed away. They can be very private, or intended for others to browse through. They can be created and given as a personal gift to the extended family or someone special.

Classic scrapbooking means that the stories the pages contain are the most important element. Your life is unique and preserving your memories is a valuable activity, both for you and for future generations. The experiences you've had, the people who inhabit your world, the sights, sounds, aromas and tastes and feelings that evoke meaningful times from your recent or distant past—all can be represented in a scrapbook. For those readers who have already been bitten by the scrapbooking bug, I would like to think that this book offers some useful hints for getting at the stories behind the objects, contemplating their meaning and documenting them in a creative way. Some of the original ideas and guidelines for making scrapbooks are intended to offer suggestions for making the scrapbook truly a classic keepsake. And for those people who have boxes of things they can't throw away, files of meaningful clutter, envelopes of developed but unmarked photos, overflowing drawers of mementos, and the intention to "someday" put a scrapbook together, I hope that this book offers some encouragement to get started. We all can identify with the problem of good intentions and too little time!

I am extremely grateful to all those dedicated and enthusiastic scrapbookers who were good enough to share their books and their thoughts with me. I hope that by letting them tell their own stories

of the various types of scrapbooks that they keep and the satisfaction it brings them, this book will be an inspiration to readers.

Vera A. Rosenbluth
September 1998

CHOOSING A
SCRAPBOOK

So how do you choose a scrapbook? Your options will depend on what kind of scrapbook you plan to make. First decide whether you would like to buy a book or make one yourself. There are many books on the market that are suited to all different sorts of scrapbooks and of course, making your own book opens up a world of possibilities.

One of the main concerns of today's scrapbookers is durability. In the past, people who kept scrapbooks rarely worried about such things as acid migration or archival quality materials (see Preservation on page 18). That has changed as scrapbookers work to make albums that will last for many years. It is possible to buy extremely durable books from scrapbooking companies, photographic supply stores, stationery stores, and museum supply companies. These archival quality albums generally come with plastic sleeves and pages you can insert and take out as necessary. Specially made scrapbook albums are fairly expensive but a good investment if you are going to be keeping valuable original documents in your scrapbook. The drawback of the heavy-duty albums is the loss of accessibility that comes from using plastic sleeves, and the fact that the albums themselves are difficult to personalize to reflect the tastes of the creator or the person receiving the scrapbook. Archival quality photo albums come in a variety of sizes and are also suitable for making scrapbooks.

Another option is to buy a regular three-ring binder and put your scrapbook pages inside polyethylene or polypropylene sheet protectors with holes to fit the binder. Binder scrapbooks have the benefit of being relatively inexpensive, safe to handle, and good for preserving pages. If your scraps are mounted using archival tape and photos are attached with corner mounts rather than glue they will be removable. The plastic pockets will allow you to display the front and the back of a document, and you can pick and choose papers to suit each page. The drawback is the same as with the specially created scrapbook albums: you cannot feel the paper or the documents,

and binders are not easily personalized. Also, investigating the contents of envelopes attached to a scrapbook page isn't possible if the page is enclosed in plastic. If you want to use the three-ring format to bind your pages you can make your own covers with lightweight board, leather, cardboard, or covered boards and three loose binder rings (available at stationery stores) to keep the covers and the pages together.

If durability is not your main concern you have an almost infinite variety of books at your disposal. Blank books come in every conceivable shape and size, and range from kids' journals filled with newsprint to magnificent leather-bound books filled with handmade paper. There is a book to fit every taste and budget.

My bias is toward handmade scrapbooks. Beautiful books are a tactile as well as a visual feast. Handmade books have a personal charm that cannot be equaled. When you make your own book every single element, from the cover paper to the binding, is a reflection of you. Scrapbooks are a very personal medium and whether yours is meant to be private or a gift for a family member or friend, a handmade book is wonderfully unique. Handmade books are not likely to be as durable as many purchased books, so they will need to be handled carefully. You might also want to use copies of valuable original documents in your handmade scrapbook rather than the real thing. Even though it may not last for hundreds of years, with the right materials and handling your handmade scrapbook will certainly last at least long enough for more than one generation of the family to enjoy it. With the right archival quality attaching methods for your scraps they can be transferred into another book, perhaps one made by your grandchildren or great-grandchildren, keeping your scrapbook memories alive for another few generations.

PRESERVATION

Think archival. That is the basic lesson for preserving and restoring scrapbooks. Most people are unaware that the majority of paper products eventually self-destruct, not simply because of normal aging and exposure to environmental damage such as smoke and moisture, but also because they contain acids and other chemicals that leach out over time. These self-destructive papers or other substances, such as glue or ink, also take the surrounding material with them when they go. The term "archival" has no set of standards associated with it. An archival quality material may last for one hundred years or it may last ten years. Because companies can use the term without defining it, here are a few terms that will help you choose a truly archival quality product.

ACID, ACID-FREE, AND ACID MIGRATION

A paper or object with a pH (acidity level) of less than 7.0 is considered acid. A paper with a pH of 7.0 or more is called acid-free. When papers are acidic, that acid will migrate or move onto less acidic or neutral materials and cause them to deteriorate more quickly.

Oil from your hands, and environmental contaminants can also make neutral objects acid and hasten their demise.

BUFFERING

To be really stable, acid-free materials should also be alkaline buffered. (If the paper isn't acid-free and buffered you can do this yourself with a deacidification spray available from museum and archival material supply companies—see the Resources section for details.) Keep in mind that even buffered materials will eventually become acid if kept next to acidic materials for a long time.

Archival quality materials should also be durable and able to withstand environmental conditions. Archival materials are also removable—that is, an archivally mounted photograph will not be glued to the page. Instead it will be attached using corner mounts.

Even if an item is acid-free it is not considered archival if it is easily damaged, or attached in such a way that it cannot be safely removed.

PAPER

There are a few things to look for when you are choosing an archival quality paper. As well as being acid-free and buffered, try to find paper that is lignin-free. Lignin is part of the plant cell which is acidic and, if left in paper, may cause it to deteriorate under light. Look for something called "permanent paper" which is an industry standard given to paper that is proven to have a pH of 7.5 or more, is resistant to wear, buffered, chemically stable, and free of impurities. In general, papers made of wood are less safe than papers made with cotton or linen.

A Note About Newspapers

Many people love to put newspaper clippings in their scrapbooks. Unfortunately newspapers are printed on very poor quality paper and disintegrate quickly. Consider photocopying articles onto acid-free paper, preferably using a color photocopier to preserve the look of the original, and putting the copy in your scrapbook. Pieces of newspapers can also be laid flat to soak in a water bath for 15 minutes to get rid of impurities and after they are dried, sprayed with a deacidifying spray (available from museum and library suppliers).

PLASTICS

If you are going to place your scrapbook pages in plastic sleeve protectors make sure that you use the right kind of plastic. Many plastics offgas (leak) chemicals which will damage papers and photographs over time. Try to use polypropylene or polyethylene sheets. Professional archivists use Mylar, which is fairly expensive.

INKS AND ADHESIVES

Try to choose an ink that is resistant to light, heat, and water and is

permanent. Some experts recommend carbon or pigma ink, which is found in archival or permanent pens. Never use staples or elastic bands in a scrapbook. Try to stick to archival quality photo edges, acid-free double stick photo tape, glue sticks, and other neutral adhesives. Remember that it is best to avoid gluing or permanently fastening any valuable original documents to the page. Instead consider photocopying important documents and using copies in the scrapbook or placing them in handmade archival envelopes (see page 187).

The following recipe for archival glue is popular with book binders and artists.

MICROWAVED WHEAT STARCH PASTE

Wheat starch paste is an ideal adhesive for bookmaking and putting materials into scrapbooks. It is easy to make in a microwave and will keep for at least a week if refrigerated.

To make Wheat Starch Paste you will need:
1 tablespoon wheat starch
 (available at book binding supply companies, museum and
 library supply companies, and some art and craft stores)
5 tablespoons distilled water
A few pieces of cheesecloth

METHOD

1. Mix the wheat starch and the water in a deep microwave-safe bowl and place the bowl in the microwave on high for 20 to 30 seconds.

2. Remove and stir.

3. Put it back in the microwave and heat it at high temperature for another 20 to 30 seconds.

4. Remove and stir.

5. Repeat the process until the paste thickens, usually 3 to 4 minutes, depending on how powerful your microwave is.

6. Let the paste sit for a few minutes to cool before you use it. At this point you may find you need to thin it with a bit more water.

7. Strain, using the cheesecloth.

STORAGE

Store your scrapbooks in a place where they will be kept dry, cool, and out of harm's way. Avoid keeping your scrapbooks in a basement or attic, and don't allow them to sit in direct sunlight.

The History of
the Scrapbook

One might think, looking at the new websites, expanding number of glossy magazines, and increasingly large sections of hobby stores and stationery shops devoted to scrapbook supplies, that scrapbooking is a brand new phenomenon. It isn't, of course. People have been keeping scrapbooks for generations. So where did scrapbooks originate and what is their history?

That would seem to be an easy question to answer, but in fact little has been written on the history of scrapbooking. Perhaps that is because scrapbooks are so intensely personal and individual that they were not considered worthy of serious study as a cultural or artistic medium. Like diaries, letters, and family stories, they tended to be kept within the small orbit of the family unit. But several threads leading to contemporary scrapbooks can be traced back quite some way.

When we look at the vast array of colorful magazines on any magazine rack, it's hard to imagine a time when printing was expensive and done only in black and white. Yet that's how it was from the time printing was invented in the 1600s until the nineteenth century. There was great excitement when die-cut glossy printed paper images appeared in the early 1800s. These color images were

commonplace book:
A book of literary passages, cogent quotations, occasional thoughts or other memorabilia.

called "Glanzbilder" in Germany where they originated and "scraps" in England where collecting them became a rage.

The scraps consisted of pretty images such as hearts, flowers, romantic couples, angels, birds, and animals, and were used in advertisements, greeting cards, holiday decorations, and the like. It was primarily women who cut them out and pasted them on their own letters and calling cards. As printing technology progressed and the scraps could be mass produced in sheets, they became more available and coveted as items to be avidly collected and pasted in albums. Scrapbook mania, Victorian style, was born!

The emphasis in these Victorian scrapbooks was on collecting new items rather than keeping things of personal significance. As such, Victorian scrapbooks were much closer in spirit to children's contemporary sticker books than to what we understand today by the word "scrapbook." Victorian children would surely have been dazzled by the seemingly unlimited choice of motifs the modern sticker industry now produces specifically for modern memory albums, including holographic stickers, "scratch and sniff" stickers, and the many stickers with holiday, birthday, and wedding motifs.

While the word "scrapbook" comes from the Victorian era, it meant something quite different years ago. Where, then, should we look for the origin of the concept of a scrapbook as we know it today?

The term "commonplace book" has all but disappeared from the language, but it used to be — well, commonplace. A commonplace book, according to the Oxford English Dictionary, is "a book in which one records passages or matters to be especially remembered or referred to without arrangement."

I first heard the term from Nichola Hall, a friend who received a commonplace book with handwritten excerpts of favorite stanzas of poetry as a gift from a friend in England. It was a very personal gift and the selection of verses revealed a great deal about the friend who sent it. And it struck me that what many people keep in their scrapbooks today, from aphorisms and sayings to favorite bits of poetry or interesting newspaper clippings, has a direct connection with the commonplace books of old.

References to seventeenth-century commonplace books abound.

One that has survived originally belonged to a minister named Mr. Sparkes who lived on the Isle of Wight and kept a book filled with handwritten notes about religious debates, the letter appointing him to his job, letters from relations whom he evidently asked for money, lists of Latin words copied from a dictionary, sermons, rules that the clergy were supposed to follow, scraps of verse, notes on the planets and the stars, and bits of folklore. It was a book much like a classic scrapbook.

The philosopher John Locke devised a way of organizing entries alphabetically in a commonplace book in 1706, and in 1820 "An Aid to Memory" was published. The 574 pages were ruled, numbered, and indexed so that the owner could fill it with reflections, ideas, memories, and excerpts of readings and songs. It even had a brass lock to ensure privacy! How similar to the vast array of formatted memory books that we can buy now, to help us keep track of the ephemera of our lives.

from a scrapbook:
The century is advanced, but every individual begins afresh.

—Goethe

The commonplace books of many famous writers have been published, revealing as much or more about them than do their biographies or autobiographies. E.M. Forster's "Commonplace Book" was compiled from 1925 until two years before his death in 1970. There's a wonderful story about how he started writing it in the first place. When he inherited a house from his aunt, he found this very large and beautiful book, bound in leather, with fine quality paper. The original owner, a Bishop Jebb, had bought it in 1804 for use as a commonplace book. However, human nature being what it is, he had written in only the first eighteen of its more than four hundred pages before abandoning the project. Forster immediately determined to carry out the intentions of the good bishop. This commonplace book contains sharp commentaries on literary readings, and, particularly in the last part, moving reflections on his own life as he aged. He includes diary entries, sketches of his kitchen garden, and poetic meditations in his commonplace book.

Other commonplace books, by authors ranging from Robert Burns and George Eliot to contemporary writers, reflect a love of language and literature and a desire to remember and preserve passages that strike a personal chord. Surely that is partially what scrap-

from a scrapbook:
What though his
head be empty,
provided his
commonplace
book be full.

—JONATHAN SWIFT

books are all about. Preserving thoughts and ideas that resonate, so one can refer back to them and remember them, is the hallmark of both commonplace books and scrapbooks. We can therefore trace the threads of contemporary scrapbooks back to the collections of visual images in Victorian scrapbooks and the bits and pieces of written passages in commonplace books.

A third thread that forms part of the fabric of today's modern scrapbook can be found in the journals and diaries that people have always kept, particularly those that reflect daily activities, thoughts, family and friends and voyages. Often illustrated by sketches, these diaries tell the stories of the events in one's life. Modern scrapbooks, filled with photos and mementos, add a visual and concrete element to the journal.

These ancestors of contemporary scrapbooks were in my mind when I visited Elizabeth Campbell to look at her grandmother's scrapbooks. The first scrapbook was one that Elizabeth's grandmother had lovingly compiled in 1940 for her two granddaughters, five-year-old Elizabeth and three-year-old Jocelyn. The large scrapbook is filled with colorful images, cut out with great care and neatly glued onto the pages. The cover is cream, embossed with leaves, and the pictures were collected from magazines, greeting cards, labels from food cartons, advertisements, and religious cards.

Elizabeth Campbell told me:

> We used to spend two weekends out of four at her house, and we'd always spend time looking at what she called her memory book. In grandmother's day there wasn't the profusion of children's books that we have now, and there was no TV, so grandmother just put this book together with not much money but a great deal of love. We'd look at it with her, or on our own for hours, and thought it was just wonderful.

The book was obviously designed to appeal to a little girl. The first pictures are of cherubic young children playing, blowing bubbles, asleep, baking cookies, and washing dolls' clothes. On each page is a title in grandmother's tidy handwriting. Here and there are printed words; the inscription "To someone I love" (taken perhaps

from a greeting card) is pasted under a sweet picture of a baby who has fallen asleep over her porridge.

Elizabeth's grandmother created a picture book in which each page or several pages contains pictures from a particular category. There are Christmas pictures, vegetables, fruits, wild animals, and horses. Images from Walt Disney lie side by side with ones from nature magazines. Cats and dogs romp through the pages. Elizabeth smiled, leafing to a picture of a small boy looking through a window at a bird's nest filled with three eggs. Under the picture, her grandmother had written, "I would not touch it for the world." Elizabeth explains:

> She was very big on nature. She had a birdhouse in her backyard, and that was the big rule, that we couldn't touch eggs in the nests. She found the exact picture to illustrate that!

I asked Elizabeth what her grandmother was like.

> She was a tall, raw-boned woman. She'd be considered a single parent today as she left her husband and raised two sons on her own, and they both became extremely successful in their fields. She was very ambitious about education. She said education was something nobody could take away from you.

How does it make Elizabeth feel to look through the book after so many years?

> I remember looking at these pages when I was very small. It makes me feel very sentimental, and it reminds me of staying with her, when it was all very cozy and nice. She believed in great meals. She'd make homemade bread and we'd put fresh raspberry jam on it and she'd allow us to sit up in her bed and eat this treat. So yes, it brings back memories of all the times I spent at her house. But the pleasures were very simple. We used to just play. Nowadays some of that gets lost when there's so much to distract children. This scrapbook was considered very, very special. I know even at the time, we thought it was magical.

With a last fond look at the pages of pictures of flowers which

from a scrapbook:
Allow children to be happy in their own way, for what better way will they ever find.

—SAMUEL JOHNSON

from a scrapbook:
If I had my mother
around now, I'd ask
her more about
her life.

—RITA MacNIEL

brought back memories of her grandmother's splendid garden, Elizabeth then showed me the second of her grandmother's books. And if the first was reminiscent of a Victorian scrapbook, the second was very like an old-fashioned commonplace book.

The second book was smaller than the first. It was clearly labeled "scrapbook," and the inside front cover bears a note on a piece of prescription paper written by Elizabeth's grandmother's brother. It was one of those scraps of paper she could not bear to throw out. "He has not lived in vain, who leaves to his friends a legacy of sweet and cherished memories." Mary Turvey, Elizabeth's grandmother, may or may not have known that many of the commonplace books of centuries past began with a quotation or epigram that was especially meaningful to the owner. Mary Turvey's name, address, and photo begin the book which is dated November 24, 1953.

Elizabeth told me, "We've got an essay of what she wrote about her life, but it's been so edited for posterity that it doesn't really capture anything of her. But this book tells quite a bit. Look at this caption that she's cut out of a magazine: 'Here is all I've counted splendid.' That's under a photo of her house on Ninth Avenue, her pride and joy, and her garden. That picture's flanked by pictures of her two sons, my father and his brother. So these were the three things that were most important to her."

What follows is a collection of things that Mary Turvey saved over the years and compiled in a scrapbook while she was in her eighties. She includes poems that touched her, many of them by Edgar Guest, "the poet of the plain people," whose poem "It takes a heap o' livin' in a house t' make it home" was Mary's favorite. There is inspirational verse about working hard and living an honest life, cartoons of the times, lots of pictures of Churchill ("he was just her type of feisty fighting kind of person," said Elizabeth) and Roosevelt, whom Mary Turvey greatly admired. There are greeting cards from her sons and friends, and articles about the city she lived in and loved.

Mary Turvey's second scrapbook should give hope to those of us who have kept scraps of things that are important but have them tucked away in shoeboxes, files, and drawers. She created the book

near the end of her life, and many of the poems and thoughts she se-lected for her scrapbook reflect a preoccupation with growing older and reviewing how one has lived one's life. At the bottom of the last page, in Mary Turvey's handwriting, are the words "The snow of winter may be on her head, But the sunshine of eternal spring is still in her heart."—MCT. No wonder Elizabeth Campbell says, "This scrapbook is really her book, her thoughts."

Many people who are being introduced to scrapbooking for the first time are excited about the methods for remembering and pre-serving experiences in a concrete and creative way. As we work on our contemporary scrapbooks, we might remember our ancestors who collected scraps for their Victorian albums, literary passages and ideas in their commonplace books, and the stories of their lives in their journals. Memories and storytelling are an essential part of our human nature, and it is wonderful to be part of such a long and rich tradition.

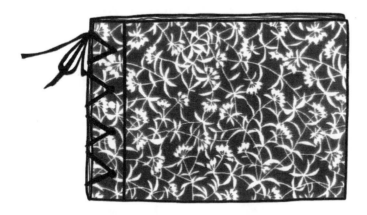

Making a Hinged Scrapbook

Hinged two-piece covers are ideal for scrapbooks because they can expand as much as needed. They are also more flexible than books with spines. You can hinge only the front cover, leaving the back cover a solid piece, or you can hinge both, depending on your preference.

To make a hinged two-piece scrapbook you will need:

Inside paper

Choose at least fifteen sheets of paper of at least 11" x 17". These can be white, black, or any color but remember that you will want to be able to write on them and so should have suitable pens and ink (i.e., metallic for black pages). Each

sheet will make two scrapbook pages. The larger the paper you use, the larger your scrapbook will be. This paper will be cut in half lengthwise (Figure 1-1) and then folded in half (Figure 1-2). Remember to use archival quality paper if you want your scrapbook to last. (See page 18 for a discussion of archival quality materials and when and why they are used.)

Cover boards

You will need three pieces of a medium-weight cover board. For archival quality board you can use museum board. You can also use mat board (which is archival on its surface) or poster board or any other similar-weight board. Remember that regular cardboard will not hold up very well, especially for a scrapbook which often undergoes a lot of wear and tear as it is being created. Your cover boards will be cut so they are the same size as your folded paper pages. For this project the back cover is one solid piece and the front cover is hinged. The hinge is made of a piece of board 1" wide, and the width of the opening front piece is as long as the back cover board minus the width of the hinge plus a $1/8$" gap (Figure 1-3).

Cover paper

Choose two pieces of paper. Many types of paper will be suitable, including most decorative papers that are medium- to lightweight. Consider using rice paper, drawing paper, or a flexible decorative paper.

Endpaper

Choose two pieces of any attractive paper. Ideally it will complement or contrast your cover paper. Good choices are marbled paper or any other decorative paper. Most art supply stores carry a selection of papers that are suitable to use as endpapers.

Cardboard

A piece of cardboard 1" wide and the same height as your pages to make a jig. This piece should have holes punched in it that will be used to mark the cover and pages so all the holes align.

Raffia or ribbon

A few feet of raffia or ribbon. The binding technique is sim-

FIGURE 1-1

FIGURE 1-2

$1/8$" FIGURE 1-3

ple but elegant and has the attraction of being easy to unbind if you want to add more scrapbook pages. Any ribbon, heavy piece of string, or heavy embroidery thread will serve the purpose. It should be at least four times as long as your book is wide.

Linen tape

You can also use a piece of linen or paper tape the length of the hinge as reinforcement. Linen and paper tape can be found at some craft or art supply stores.

Paste or glue

You can use regular white glue (which will probably not be archival) or wheat starch paste (see recipe on page 20), methyl cellulose, or another suitable archival quality paste. Ask at your art or craft supply store which adhesives will show when dried and which are archival.

FIGURE 1-4

Two C-clamps

These should be large enough to comfortably grip your scrapbook with all the pages inside the cover board.

Needle

A needle with an eye large enough to thread your ribbon or thread through your book.

A drill or awl

Pencil

Ruler

Scissors

Book press or heavy weight

FIGURE 1-5

METHOD

1. Begin by cutting each sheet of paper in half lengthwise and then folding them in half (Figures 1-1 and 1-2). These will be your interior scrapbook pages.

FIGURE 1-6

2. Cut your back cover board so it is the same size as the text pages. The front cover board will be two pieces (Figure 1-3).

3. Cut your cover paper or fabric so it is 2" taller and wider than the interior pages (Figure 1-4).

4. Cut your endpapers so they are ¹/₂" narrower and shorter than the cover boards (Figure 1-5).

5. Arrange the front cover boards so that there is a ¹/₈" gap between the smaller and the wider piece. The ¹/₈" gap for the hinge works for most thicknesses of cover board. If you are using much heavier cover boards the hinge should be one and one-half times the board's thickness. If you wish you can reinforce this empty space, which will act as the hinge, with a piece of linen tape before you paste on the cover (Figure 1-6). The tape goes on what will be the front of the cover. Paste the two front cover boards onto one piece of cover paper (Figure 1-4).

Figure 1-7

6. Fold cover paper on each corner as shown (Figure 1-7). Pull the paper as tight against the edge of the board as you can without tearing it. Paste these corners down.

7. Fold down each of the sides and paste down, forming tidy edges (Figure 1-8).

Figure 1-8

8. Wrap the covers in wax paper and put them in a book press or under a stack of heavy books.

9. When the covers are dry and flat cut the endpapers so they are ¹/₂" smaller all around than the cover boards. Paste them down, centered on the boards (Figure 1-9). Press the cover boards with endpapers attached in wax paper until dry.

Figure 1-9

10. Tear or cut enough 1" strips of paper to place between your scrapbook pages as needed (Figure 1-10). These will ensure that even after you place photos and other mementos into the book it will still lie flat. The extra paper will also act as reinforcement for your pages so they are more likely to last. (If you are using single

sheets of paper rather than folded pages, if you measure them 1"
longer than necessary, you can fold the extra inch over for the
same effect.) This step is optional and not necessary if you are
using very heavy paper.

10. Fold your scrapbook pages and place them between the front
and back covers using your clamps to hold them securely. To
prevent the clamps from marring your cover paper, put a piece
of folded paper towel between them and the cover.

 Mark and punch four holes an equal distance apart, using your
 awl or hole punch.

 Thread your ribbon or string through the holes as shown (Fig-
 ure 1-11) and finish with a bow at the back of the spine (Figure 1-
 12). This binding technique is more secure than one that uses
 only two holes, but is still simple to undo as you need to add
 pages.

FIGURE 1-10

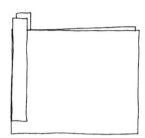

FIGURE 1-11

HINTS AND TIPS

A Note About Gluing

Even the most careful scrapbook maker will probably find
that air bubbles mar the cover and endpapers of your book. To
minimize these, gently but briskly rub on the glued papers
with your fingers from the middle toward the outside. Most
air bubbles don't show right away but take a few moments—
usually until your glue has dried enough that you cannot re-
move the paper! Rubbing the paper will help to get rid of the
air pockets, and pressing them with a book press or heavy
weight for at least a couple of hours is a further help. When
you are gluing an end sheet in which one half is left free,
make sure not to press it against the glued cover as the mois-
ture will cause it to warp (Figure 3-2).

FIGURE 1-12

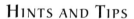

CORNER VARIATIONS

You have a few options for folding your cover paper onto the boards. The method shown above is called the "universal corner" and it is the basic corner used by most bookmakers. It is most suitable for cloth and thin papers. Two other methods for making corners are shown below. They are both examples of "mitered corners." The corner shown in figure 1-16–1-17 is most suitable for heavy paper. Making neat and tidy corners will probably require some practice and patience, so take your time.

FIGURE 1-13

FIGURE 1-14

FIGURE 1-15

FIGURE 1-16

FIGURE 1-17

The Pleasures and Rewards of Scrapbooking

I have yet to meet a scrapbooker who doesn't speak of scrapbooking with passion and enthusiasm. People get enormous enjoyment from creating a book of memories, and great satisfaction from looking through the finished volume. The joys and benefits of scrapbooking are varied and interwoven, and valuable for many different reasons.

Each of us lives a life that is unique and full of stories that define us, connect us with others, and give us a sense of personal identity. Stories come from our families and friends as well as our own lives. Stories enable us to make sense of the past and light the way to the future. We need some way of preserving those important stories, whether in writing, on video- or audiotape, or by photos and other objects and memorabilia that help us record and remember our lives. Life experiences are ephemeral, and we need tangible touchstones for our memories. Scrapbooks are an ideal way to keep the stories and artifacts that matter.

At a recent lecture I attended, Ivan Head, a law professor and political advisor, remarked, "It is the nature of human beings to be archivists and toolmakers." Since the beginning of time, people

have kept various types of records, both public and private. Modern scrapbooks are part of that private record-keeping. As physical objects, scrapbooks also satisfy that very human desire to create something meaningful that one can hold in one's hands and even pass on to future generations. Whether the scrapbooks are enhanced archival quality albums with intricate layouts and color-coordinated paper, or more simple traditional scrapbooks, there are pleasures and rewards in the process of making a scrapbook and in looking through it years or even decades afterwards.

Each person is a
unique tapestry
of the past.

—R. R.

ARTIFACTS AS TOUCHSTONES
FOR MEMORY

Part of the attraction of scrapbooks is that they are informal and flexible. Of course, what one finds meaningful is very individual, so each scrapbook is by definition unique and the artifacts kept in it will kindle very personal memories. Sandy Goodall has many scrapbooks, starting from ones she did as a young girl and continuing through her life. We talked about the value of looking at them now.

> It's your whole life that you see when you look at these things. I just imagine myself when I'm one hundred years old and can't do a lot of things anymore. I'll sit and have my scrapbooks and photo albums heaped around me and it will be a great comfort. The things in the scrapbooks remind you of everything you've forgotten about. By having these little ticket stubs or programs or any of these things in the books, it brings back the whole occasion. If you have things your kids made, it brings back all the neat little things you just adored about the kids. So the memories just flow back. To have these tangible things in front of you, that was your life!

Ninety-one-year-old Evelyn Horton wrote me several charming letters describing her lifelong fascination with scrapbooking. "In looking over my beloved albums I see a long lifetime of interesting events, thoughts, humor, etc., to remember and cherish. The albums were (and are) made for myself but with the thought that hopefully grandchildren would enjoy them too."

LEAVING A LEGACY

Some of the people I talked with were absolutely clear about the imperative they felt to keep scrapbooks of their lives. When I asked Bill Terry how he would feel if he traveled and did not document it, he said firmly,

> I would just feel that I hadn't completed the job. I have to do this. It's absolutely a form of archiving, and in a way we don't leave much behind, so this is perhaps our one way of achieving some sort of immortality. We were here and this is a record of our passing. And these scrapbooks are so important to me that if the house were burning down, I think they would be the first things I would rescue.

Especially these days, when there is a strong emphasis placed on archival quality materials, there is a profound sense among scrapbookers that what they are doing is for the future as well as the present. There is an awareness that while previous generations grew up knowing their family stories, that is probably less true now. Family mobility, changes in the definition of a family, and speeded-up lifestyles that leave little time for sharing stories mean that people have to make a concentrated effort to retrieve and preserve those important connections. Often one person in the family takes on the role of "family historian" and investigates the genealogy or does oral history tapes or makes the scrapbooks for future generations.

In Reesa Margolis Devlin's family, she is definitely that person. Her mother died less than a year ago, and Reesa is taking her place as the family storyteller.

> My mother was the person who knew everybody for generations back, and how they were related and what they did. She's recently passed away and I've got all these things, the archives, the history of the family. And going through them, so many things are becoming so much more important. You know, just the fact that my mother's no longer there to tell me stories, and all of a sudden I think, gosh, I remember her telling me about this, and I wasn't paying attention because it was the hundredth time she told me the story. And now she's not here. And I'm

It means more to have it in a book. It's about me, it's about who I am, where I've been and the steps I've made. And I'm realizing that what's also important is the whole business of sharing.

—M. V. B.

thinking, what about when I'm older and my kids want to know? So all of a sudden, preserving those memories and the whys and where things came from becomes so much more important. I want to do what I can with my own history so when my kids reach that age they'll look back and have stories to tell and things to hand down to their children and they can say,: "This belonged to your grandmother."

Sandy Goodall is a survivor of breast cancer. She told me that it was the cancer that pushed her to get her photo albums and scrapbooks up to date.

> When the kids were growing up I saved everything they made in boxes. Things they made themselves, Mother's Day gifts and things like that. I saved them all, but was just too busy to put them in books. After I got sick, I realized that I had an attic full of great stuff and I'd better get going and try to get things organized. I realized that life does not go on forever. But I'm going to get the photographs organized. So I did.

Sandy had photos dating from 1963 that were still in their envelopes. (That should give hope to some of you who despair of ever getting caught up!) She ended up with thirty-seven photo albums and several bulging scrapbooks.

> Then I wrote down as many family stories as I could remember. I started writing my life story. I'd go up to our cabin and write down my life because I thought I'd like to leave this stuff behind.

One of the scrapbooks is of special significance because it is filled with cards and letters sent by Sandy's friends during her illness. She found them difficult to read while she was fighting the illness, but now treasures the love and caring reflected in them. I asked her what she feels when she looks at the scrapbook now.

> All good things. Everything you see in a scrapbook is nearly always a good reminder, don't you think? Well, the illness was a bad experience, but the good part of it is coming through it and carrying on.

Consciously or unconsciously, many people, particularly as they approach and pass middle age, make scrapbooks in order to leave

It's easy to say this is the guy I married, and these are the kids I have, and this is the job I have. To capture who you are as a person is a whole other thing.

—A. B.

something of themselves behind. As we recognize and accept our mortality, it becomes a matter of importance to create something tangible and lasting of our own life.

MAKING CONNECTIONS

I keep coming back to the word "connections" when I think about the value of scrapbooking. As an adult, looking through a scrapbook you made as a child, you can connect with that younger version of yourself. Your childhood scrapbooks can be sweet, enlightening, sometimes embarrassing insights of the child you used to be, and are suffused with myriad memories and emotions.

Kerry Howard, a young grandmother with a very close knit family, told me about the scrapbooks she kept as a child.

> When I was eleven or twelve I collected pictures of animals, then graduated to pictures of horses in their breeds and categories. I got the pictures out of the *Western Horseman* magazine. The book was a lovely big brown scrapbook with a picture of an Appaloosa on the cover. After my father was killed I wanted a horse desperately, and that's what started my scrapbook. My mother was a single mom and worked very hard, and when I got my allowance I remember I used to run downtown— this was in the days when girls of twelve could go off on their own— and I used to buy the *Western Horseman* magazine and cut it all up, take all the beautiful pictures out. I was an only child for nine years, so part of making it was amusing myself. There was no TV, so in the evenings I read and worked on my scrapbook. I can see the room I had when I was cutting out the pictures. It does bring back memories of growing up.

Sara Jewell now looks at the scrapbooks she made as a teenager and notes the pictures of movie stars, an article about kissing, another about the ideal body type, an ad for lipstick, and is intrigued to see what it reveals about her teenaged self.

> I want to start a career writing romance novels, so it's interesting to go back through the scrapbooks and see how fascinated by romance I was as a teenager. I got away from that. If I'd stuck with it, I might have published ten books by now!

from a scrapbook:
What was silent in the father speaks in the son; and often I found the son unveiled the secret in the father.

—NIETZSCHE

My Aunt Mill used to
love to laugh. If some-
thing made her smile,
she'd cut it out for
her scrapbooks.

—S. J.

Another type of connection is made if you are lucky enough to have a scrapbook made by a parent or grandparent, and are able to gain some understanding or insight into that person. Elizabeth Campbell, whose grandmother's scrapbooks are described in some detail in the previous chapter, also has five books that her father left her. They are small hardcover books with the heading "Scraps," dated 1927 and stamped with the words "Children's Hospital" where he worked as a doctor. They are filled mostly with excerpts of things he read and liked and copied out in his neat handwriting, but also postage stamps, lists of people he knew, pages of word definitions, his selection of the greatest sonnet writers and the greatest English dramatists, and miscellaneous other notations.

Looking closely at these books for the first time in many years, Elizabeth mused over the choices of quotations from Paul Verlaine, John Milton, Bertrand Russell, Samuel Butler, Lord Chesterfield, Robert Louis Stevenson, Oscar Wilde, and Rupert Brooke.

> He was a great reader, even though at the time he was having to tutor the sons of rich men. Father earned his money for his studies that way. He was also playing professional hockey to make money because he was trying to put himself through medicine, support his mother, and help his brother. So to have time to be reading all this and writing it out, is amazing!

I asked Elizabeth whether the books gave her any new insight into her father.

> Well, I knew about his tendencies to be hardworking and thorough and precise. And I knew he liked language. He trained as a doctor and never had the luxury of going to university and studying whatever he wanted. So in this way I guess he's making up for it. I can't believe what he's done here. It's an awful lot of effort.

An effort, yes. But clearly an effort that was rewarding and satisfying for Elizabeth's father, and a source of pleasure and family connection for Elizabeth.

CREATING SOMETHING BEAUTIFUL

One of the key pleasures of scrapbooking, particularly as it is practiced these days by growing numbers of people, is the physical appearance of the book. Colored papers, stickers, ornate printing in colored pens, borders, and cropped photos are combined to create truly unique scrapbooks. Testimonies fill the pages of scrapbooking magazines and scrapbook addicts share their enthusiasm on the Internet as more and more people find unending hours of pleasure in the creative aspects of scrapbooking. For some people, the way the scrapbook looks is the key to their feeling of satisfaction and accomplishment.

Sandy Goodall began keeping a scrapbook when she was a child over fifty years ago. "I used to save everything: ribbons from high school, programs from concerts, ticket stubs, that kind of thing. I just loved paper, glue, and scissors, and used to enjoy pasting things into a book. I think that's why I ended up being a teacher."

The pages of Bill Terry's scrapbooks are arranged with the greatest care.

I try to make it aesthetically pleasing.

—J. P.

> I do try to make this very appealing to the eye. I try to vary the layout and in some cases to fill the entire page. I cut photographs up into different shapes and small pieces and make montages. So I'm thinking page by page very much about the layout. Here, for example, is a color photocopy of my son's degree from Harvard and there is a cutout photo of him in his mortarboard, stuck on the edge of it to create a balance. Sometimes a page has no particular purpose except to show one person. Here's an entire page of photos of my daughter. I've included lots of pictures of the flowers from our garden as a context. It's not exactly an event, but it's her at the time. I usually begin each book by creating a collage of people, family mostly, and just fill the first two pages. I put in maps when we travel. Some of the travel stuff has a journal included. When we travel, and we travel quite a lot, you will know where we've been because I include dates, places, and photographs with the maps.

No matter how simple a scrapbook is, it is generally put together with some care and attention to how it looks. Even articles and ob-

jects pasted in newsprint scrapbooks years ago were done with some thought to layout and design. A special picture on the cover, a wise saying to start things off, or a carefully crafted title page made it clear that here was a unique and personal book.

One of my favorite stories about a handmade scrapbook comes from Barbara Cook, now in her seventies. When she was a child growing up in New Zealand, she made a scrapbook for primary school, using the brown paper in which bread came home from the bakery. Barbara remembers carefully flattening each piece of paper, punching holes in it, and binding it with string. As she said, "This was before office supply stores." When I asked her what adhesive she used for the clippings and pictures in her book, she remembered the flour and water paste which she mixed up and used. Despite the fact that archival quality products would not come on the market until more than half a century later, this little book filled with pictures she cut out of the rural New Zealand newspapers has stood up remarkably well.

The classic book arts of paper-making, cover design, and bindings enjoy widespread popularity, and these skills combine very naturally with an interest in scrapbooks (a recipe for wheat glue, much like the one Barbara used, is on page 20). What could be more satisfying than making one's own memory album from "scratch"?

From a scrapbook:

In character, in manners, in style, in all things, the supreme excellence is simplicity.

—Henry Wadsworth Longfellow

KEEPING CLIPPINGS
AND MISCELLANY

For some people, the pleasure of scrapbooking lies in the collection of articles, poems, and miscellaneous items from newspapers and magazines. This was more common in older scrapbooks than in modern ones. In some cases they reveal a broader focus—a general interest in public ideas and affairs of the day—than contemporary scrapbooks which tend to focus more narrowly on personal and family life. Somewhat like commonplace books, these scrapbooks provide a way of collecting the odd bits and pieces that one comes across and wants to keep. A book like this is kept primarily for one's own pleasure and satisfaction, but can reveal a good deal about the

tastes, opinions, and sometimes sense of humor of the person who made it.

Sara Jewell, a woman in her twenties, told me, "I come from a long line of scrapbookers." She invited me to look through the scrapbooks that her mother and great-aunt kept. Her mother's family were grocers, and used old wooden cheese or orange crates to hold the precious scrapbooks. "I remember that there were always scrapbooks around, no matter whose house I went to."

Her great-aunt Mildred's scrapbook was a treasury of clippings and images.

> When she found something interesting in a magazine, a recipe or joke or a poem, she'd cut it out and put it in the scrapbook so she could always look at it. The poem, "Casey at the Bat" was one she liked.
>
> She was very religious; she played the organ at church and lived her life according to Christian values and a lot of this stuff she would have cut out because it was motivational or inspirational. But she also loved to laugh, so as long as it wasn't a dirty joke then it was fair game. If it made her smile, she cut it out.
>
> Sometimes she just cut out beautiful pictures, things that appealed to her, like this picture of a violin, and flowers in a pitcher. And she saved funny images like an ad for alphabet soup with a little boy with his face screwed up!

We all come across images and ideas in our daily lives that speak to us in some way, reflect something important to us, or strike our fancy or our sense of humor. Maintaining a scrapbook for those random but meaningful scraps is a method that many people use to select from the overwhelming mass of written and visual material that enters our lives on a daily basis.

RECORDING ACTIVITIES
OF FAMILY AND FRIENDS

Sara's mother Lynda kept a more personal scrapbook in which she put local news clippings, particularly if they mentioned activities of her family. For example, there were birth, death, and wedding an-

It was a way of charting my adventures, putting it all together, a way of remembering.

—A. B.

nouncements of friends and acquaintances. Sara's father was a funeral director, so every time there was a funeral in the small town they lived in, his picture would be in the paper as part of the funeral procession, and these pictures found their way into the scrapbook.

There were cards and notes accompanying the clipping of Sara's birth announcement, and later, small newspaper articles that recounted sports achievements by Sara and her sister.

> In small-town papers, everything gets published. Everything counts. And we just cut everything out. If our name was in it, we cut it out. We kept everything, and instead of keeping things in shoe boxes and drawers, we'd paste them in someplace so they'd be organized and we'd be able to look at them.

As we looked through her mother's scrapbooks, Sara commented:

> All my mom's scrapbooks are very precious; they're our family history. They're our connection to Aunt Mill and that's part of the thing about doing a scrapbook, that when you're dead and gone, the scrapbooks remain.

For many people who keep scrapbooks, this may be the most important function of scrapbooks: to preserve memories of family times, to chart the birth and growth of children, to make a family chronicle so that stories and events won't be forgotten.

A WAY OF DOCUMENTING
ONE'S OWN LIFE

And what does Sara keep in her own scrapbooks? A bit of everything, really. Her scrapbook is somewhat more personal than either her mother's or her great-aunt's, but her approach is equally eclectic. She remembers collecting the scrapbooking materials and sitting in her bedroom putting the books together as a teenager.

> My scrapbooks have always been ongoing. The scrapbook sat on my desk and when I had something to paste in it, probably on a Saturday afternoon when I was supposed to be doing homework, I'd do my scrapbook. If I saw something I wanted to keep, I knew where to put it.

Scrapbooks let you reflect back on the past. Yesterday's gone, the page is turned, you can't add to it or subtract from it, that's it.

—R. W.

Some of my early scrapbooks are here. There was a phase I went through when I was fascinated by Arnold Schwarzenegger and all his movies. I've got pictures of him all throughout my scrapbook. I was sixteen or seventeen at the time; now looking back at it ten years later, it's kind of embarrassing.

Leafing through some early scrapbooks, Sara remarked:

These are ads for movies that I saw. I still do that now. If I see a movie, I cut out the ad for it, just as a reminder. Sometimes I add the ticket stubs.

These are all guys I had a crush on in public school before I moved. Even when I moved away I got the local paper and they were always in the paper so I cut them out. I was very excited to have them in my scrapbook. I still am. I still smile to see them.

Sara also keeps journal/scrapbooks which are done entirely for herself, not to be shown to others.

I had my heart broken really badly many years ago so I started this book. A lot of stuff at the beginning is me trying to deal with the relationship, a lot of inspirational songs, trying to get back on my feet. There are pictures, poems, cards, drawings. and journal writing. Everything in here is very private. This would never be shown to anybody. Never.

I have always scrapbooked. I have always cut out things and wanted to keep them someplace. It's just something that has always been part of my life.

I'd forgotten this stuff! Just looking through it, the memories come alive.

—A. B.

MAKING ORDER OUT
OF CHAOS

For some people, the pleasure of scrapbooking lies in creating order, finding a way to organize the pictures and mementos that one has accumulated over a period of time. Most of us are familiar with the feeling of being "behind" with the photo albums (whether that means half a year or twenty!) or having a basement full of cardboard

boxes containing children's art. Whether to "scrap" or "scrapbook" can become a big issue!

Violet Burgess, seventy-two, found herself with three large cardboard boxes on the top shelf of her closet, labeled "Violet's Life Story — to be sorted." Two years ago she decided to tackle the job. She started by organizing piles of programs, bulletins, clippings, pictures, thank-you notes, and other mementos of her life as a girl, a wife, a mother of six, and a grandmother of twenty-nine.

> All this effort brought back many memories as I relived a concert or a child's graduation. I shed a few tears and had the odd chuckle. The hours I had planned for the project turned into days. The days turned into weeks and then the scrapbooks started to come about.

To give an idea of what stories lie in these books, I asked Violet about a small envelope with four streetcar tickets dating from her childhood. What did that bring back for her?

> The tickets cost twenty-five cents for four adult tickets, and twenty-five cents for ten children's tickets. I can see my mother and myself getting on the streetcar. We used to live in the West End and my father had a café up on Fraser Street, so my mother used to take the streetcar from Robson Street all the way up to Fraser and work with my father in the café. The streetcars were on tracks, so they would stop and the traffic would just have to stop to let you walk from the curb and get on. There was a little farebox and the conductor stood behind it and called out the streets. I can still hear the conductor's voice.

Violet created over twenty-five scrapbooks and clearly treasures each one. Making them gave her a great deal of enjoyment and stirred up a lot of memories as she put the scraps into books. And now when she looks through them, the stories of her past are brought to life.

COLLECTIONS AND
REFERENCE BOOKS

Scrapbooks can be used to organize collections of a particular area of interest or hobbies. Mike Carruthers has a hockey scrapbook he

I have always scrapbooked. I have always cut out things and wanted to keep them someplace.

—S. J.

put together when he was sixteen years old. The scrapbook is a three-ring binder and several hundred pages of lined foolscap paper on which Mike taped newspaper articles about games, and one precious ticket stub from a game he attended. The rest of the pages were carefully laid out, with each NHL team covering two pages. The scrapbook is filled with hand-drawn hockey crests and pictures of the players cut out of newspapers and pasted on the grids Mike drew. It is obvious that hours were spent in the creation and perusal of this treasure.

Eli Howell, growing up in Europe in the 1920s, made a scrapbook of matchbox covers which he organized carefully according to the country of origin. Miraculously, that scrapbook has endured for over fifty years in relatively good condition!

Anything that is more or less flat and not too thick can be preserved in a scrapbook. Wine bottle labels, coasters, cartoons, poems, pictures of birds and animals, all fit nicely in the pages of a book.

Related to hobby scrapbooks are reference scrapbooks. Alleyne Cook is a retired landscape gardener with a passion for rhododendrons. His scrapbook contains useful articles and tips about horticulture. Alleyne also keeps articles he has written for a variety of gardening journals. He also uses his gardening reference/scrapbook to keep political cartoons that tickle his fancy, articles about people he knows, and sundry other little clippings. Pointing at a page he said, "Here's an article about words that were invented by Shakespeare that we use today. More articles about gardens. An article about insects. Lots of family pictures."

I commented to Alleyne that some people might separate articles about gardening from pictures of the family, but he didn't seem bothered by the juxtaposition. "Here's something I just cut out: the difference between red, black, and brown birch. This man said that the bark of a red birch is silver, but the timber is pink when it's green. Brown birch often has black bark but the green timber is red. And sometimes the bark of a black birch is white but the timber is yellow and sometimes it's brown when it's green. It's just a little confusing."

From the child who keeps a scrapbook of pictures of dogs care-

These are wonderful books because they combine the personal and professional sides of me. They are the ongoing story of my life.

—B. D.

fully arranged according to breed, to the young man whose scrapbook is filled with pictures and articles about canoes and canoeing, people love to make books of their personal passion.

Although scrapbooking is not a new activity, the explosion of interest in memory albums in the past few years invites speculation. Why are so many people redoing their old photo albums and spending vast amounts of time as well as money on new albums? We live in a time when our personal stories are in danger of being lost. We take endless rolls of film and collect paper brochures, tickets, programs, postcards, and greeting cards. Children's art threatens to overflow drawers, files, and boxes. We have a hard time keeping up with the sheer volume of precious memorabilia. As we age, we are more aware than ever before of the passage of time: our children are growing up and our parents getting older, and we long to hold on to what is important in our personal or family life. We need a tangible way of preserving our experiences so that they don't fade from our memories and disappear into the mists of time. Scrapbooks offer a personally made container for all these myriad stories as well as a method for selecting and organizing mementos that will be touchstones for our memories in the future.

Making a
Peekaboo Scrapbook

Peekaboo windows make particularly attractive scrapbook covers. This project uses metal posts and two hinged cover boards. The posts make it simple to add pages as necessary. The window in the front cover will enable you to hint at the theme of your scrapbook, so choose your cover photo or image carefully.

To make a peekaboo scrapbook cover you will need:

Inside paper

You can use either folded pages or single sheets of heavy paper such as cardstock or watercolor paper for this project. The post binding tends to be more secure than sewn bindings. If you are going to use

single sheets of paper you will need at least twenty sheets to make your book thick enough to use posts.

Cover boards

You will need four pieces of a medium-weight cover board cut so that they match the size of your paper, including the gap for the hinge. The hinges on this project are 1 1/2".

Cover paper

Choose two pieces of paper or cloth the same width and 2" taller than the main section of the cover boards (Figure 2-1).

Spine cloth

You will need two pieces of cloth 2" taller and wide enough to cover both the spines and at least 2" of the main part of your cover (Figure 2-2). The spine cloth should be strong enough to withstand the wear and tear it will undergo as a scrapbook cover. One option is binder's cloth, or you can go to your local fabric store and choose a medium-weight fabric that suits your cover paper. Buy a bit of extra fabric in case you decide to cover your posts so they match the spine of your scrapbook.

Endpaper

You will need two pieces of paper 1/2" shorter and 1/2" narrower than the covers.

Cardboard

A piece of cardboard 1" wide and the same height as your pages to make a jig. This piece should have holes punched in it that will be used to mark the cover and pages so all the holes align.

Posts

You will need two to three posts. The length of your posts will be determined by the number of pages in your book.

Paste or glue

Two C-clamps

Hand drill or awl

Pencil

Ruler

Utility knife

Scissors

Book press or heavy weight large enough to press your covers as they dry

FIGURE 2-1

FIGURE 2-2

METHOD

1. Cut the cover boards so they are the same size as the text pages, including the gap left for the hinge.

2. Cut your cover paper or fabric so it is 2" taller and wider than the interior pages.

3. Cut your endpapers so they are ¹/₂" narrower and shorter than the cover boards (See Figure 1-5, page 33).

4. Find the center of the front cover board and make a square or rectangle the right size to frame the image you want to display. You should make sure your window is at least ¹/₄" to ¹/₂" smaller all the way around than your picture to leave a lip for gluing.

FIGURE 2-3

5. Using a sharp utility knife, cut the window out of the front cover (Figure 2-3).

6. Glue the fabric for the spine to the spine and front cover. The fabric should extend at least 2" onto the front cover. Do the same to the back cover.

FIGURE 2-4

7. Glue the cover paper to the cover boards and hinge fabric (Figure 2-4).

8. Cut into the cover paper so you can open the window (Figures 2-5 and 2-6).

9. Turning the front cover over, glue your photo or other image so it shows through the window.

FIGURE 2-5

10. Fold and glue the outside of the cover paper.

11. Wrap the front and back covers in wax paper and let them dry under a heavy weight.

12. Apply the endpapers. Let them dry.

13. Make a jig to measure out the holes in your covers and pages for your posts.

14. Punch holes in your pages and the front and back covers using an awl or hole punch.

15. Insert the posts. These can be covered with small pieces of fabric or left plain (Figure 2-7).

Figure 2-6

Figure 2-7

Chapter Three

The Challenges of Scrapbooking

A scrapbooker once suggested to me that the world is divided into two sorts of people: those who are sentimental and save things, and those who are more practical and throw them out. I would suggest also that there are two sorts of savers: those who are organized about how they save things, and those who aren't. Over the years, it is possible to collect a good deal of miscellany and sometimes the sheer volume of it can be overwhelming. We clip things from newspapers, create piles in various rooms of the house, leave photos unlabeled in their envelopes, tuck the hand-drawn Mother's Day card into a novel we're reading, create a file in the filing cabinet called "For the Kids' Scrapbooks," and feel guilty because the piles are growing larger. I speak from experience.

This chapter is for those of you who do keep things but find it hard to get around to putting them in scrapbooks. We'll look at some of the obstacles and reasons that people have for procrastinating, and try to suggest some strategies for overcoming them.

FINDING TIME

There's no question about it—scrapbooking takes time, and in our busy lives, that is sometimes a very scarce commodity.

from a scrapbook:
Never look back;
something may be
gaining on you.

—SATCHEL PAIGE

Elizabeth Campbell, whose grandmother left her the loving legacy of her scrapbooks, told me:

I've been highly organized about putting the photographs in albums. Since the children were born they've each got their baby books and they each had photo albums as well as a set of scrapbooks. We used to ask my mother why she didn't get her photos organized, because she kept them in big boxes under her bed. And she would say, "I know I should do it but I just can't get around to it...." And then she said, "But my mother used to spend every Sunday upstairs in the den after church and after lunch, sticking pictures in her album." Mother said it was just so boring, and so irritating that she never did it. And then of course consequently when she died we had all these boxes of photos, really old photos from the turn of the century. We just don't actually know who the people are. But I've gone to the other extreme. I've been very organized.

Christena Docherty agrees that scrapbooking sometimes skips a generation.

There's a generation of my parents where it didn't happen. We moved a lot and had a big cardboard box that they threw pictures in, but Mom was busy and didn't keep baby books. They didn't do any of that stuff. I was the one who went through the pictures and started organizing them. I think I did it for my kids because I didn't have it myself. I love doing it and seeing the results. The kids love it! They look at their baby books and photo albums all the time. My oldest daughter found an album with a picture of me with an old boyfriend, and she was astounded: "You had a boyfriend?" So then I had to tell the whole story, that it was before I met Daddy and so on. They love to hear all that kind of stuff. My parents didn't have any evidence of a past life.

Christena was inspired by a home scrapbooking party she attended and has many friends who are as absorbed by the activity as she is. "I keep everything in a box, and when the kids are in bed I can pull it out and do a few pages."

Reesa Devlin follows in the footsteps of a busy mother. I asked her how she finds time to do all the scrapbook projects she has undertaken.

I think if you're a person who likes to keep busy, you find time for everything. And if you're not a person who likes doing projects, you find time for nothing. I'm amazed when I look back on my mother's life, at what she accomplished in working and raising a family: Hadassah president for twenty-five years, writing a poem or story or song for everybody's birthday, anniversary, every meeting. And she fit it all in on top of living with a very demanding husband. The minute he walked in the door, she had to be there for him. She couldn't go off to write or talk on the phone. And she accomplished so much!

When I asked Reesa how she budgets time for her scrapbooks, she said, "I do little bits at a time, and have lots of things pending. I learned years ago to go by my moods. If I set aside time to do it and am not in the mood, it's a waste of time."

Reesa makes a good point. You have to be motivated and approach scrapbooking with a positive outlook, not as if you are doing yet another chore. If you see it as a priority in your life you will make time for it, no matter how busy you are. Then whatever time is available will be productive.

The key to finding time is to think how you work best. Can you spend a weekend with a box of things you've kept that you want to sort and put into an album? Or can you take a week off, perhaps get away from your home to a cabin, and just focus entirely on putting scrapbooks together? Alternatively, can you break your projects down into manageable chunks and do a little bit every now and then? Probably most of us fall into the last category. If we don't try to do everything at once, but think about what's actually possible in the time we have available, there's a far greater chance of success.

Perhaps the issue is not finding time, but making time. As Doramy Ehling says succinctly: "Yes, time is a huge crunch factor. But I think if you don't do it, you regret it later."

GETTING ORGANIZED

Closely associated with the challenge of finding time to make scrapbooks is the issue of organization. Creating a scrapbook from a jum-

I regret that I didn't start it at a really young age, because it would be nice, even going back to teenage years, to have this chronicle. In fact I didn't start mine until 1977, but I've kept it very meticulously from then to this day and will continue.

—B. T.

ble of things dating from different decades is an overwhelming task that will require a great deal of organization before it can be tackled.

Violet Burgess, whose twenty-five scrapbooks were mentioned in Chapter 1, told me how she went about organizing her lifetime's worth of material. She started with three large cardboard boxes that contained hundreds and hundreds of items.

> Originally what I was going to do with the boxes was pick out enough stuff so I would have two binders two inches wide across the back. And that was going to be my life story. I sorted stuff out in our living room and dining room. I took out one item at a time and made little piles that related. Like school programs in one pile and church bulletins in another pile, and programs from funerals, wedding invitations in another. The number of piles grew and grew until they were lined up in rows over the living and dining room floor and on the table. I then put each pile in order by date. I thought I could do it in about two days, and it ended up taking me almost three weeks. It was such a big job. And every so often I wondered, "Shall I just throw it all out or shall I do something with it?" And the things you collect — I never wanted to throw anything away. It was hard to turn my back on it, so I thought I'd carry on and make my scrapbooks. So what happened was that I started with the things that were the oldest, like programs from music concerts when I was a child, a little sachet I made for my mother at a child's playschool, a picture of the English Bay bathhouse where we swam in the ocean, streetcar tickets in an envelope.

The sheer volume of material Violet had collected seemed a challenge to organize, but putting it in scrapbooks in chronological order made it quite manageable. The chronologically ordered scrapbooks also make it much easier for her to go back and revisit her past at any particular point in her life.

As Violet showed me her scrapbooks, I realized that there were stories and memories behind every single scrap of paper that she saved. An envelope marked "Great Depression" which contained some newspaper articles and prices from a public market (butter at 3 lb. for 59 cents, sugar at 5 lb. for 25 cents; cod, salmon, or sole for

From a scrapbook:
If you always do what
you always did,
you always get what
you always got.

—ANON

6 cents per pound, lamb shoulder for 9 cents per pound) prompted this story:

> Of course wages were low and jobs were scarce. I remember working at Woodward's Department Store on "99 Cent Days." I had to be there about half past eight and I stayed there till six o'clock and worked all day for $1.50 and I'd have to pay my streetcar fare out of that.

If you have ever tried to sort through a box of old letters and ended up several hours later, in tears or laughter having read them all, but really no further ahead in terms of sorting, you will understand why it takes so long to organize things that have been kept from long ago. Each item is a touchstone for a memory, and each one evokes a story.

What many people do is to purchase a box of large manila envelopes or file folders and organize things before they begin to put the scrapbooks together. Although shoe boxes are fine for the short term, ordinary cardboard contains cellulose. It is therefore acidic and can damage its contents over time. One can now buy attractive acid-free storage boxes divided into compartments, which are very useful for organizing material for scrapbooks. For more information on archival materials, see page 18.

You might group your clippings chronologically and have an envelope for each year. Or you might group things thematically, if that's the organization you want for your scrapbook. Some people keep a large box of their children's treasures, and at the end of the school year sort them out and record "a year in the life" of the children. As long as the boxes, files, or envelopes are clearly labeled, they will be easy to work with when you are ready to put things into the scrapbook.

FINDING A WORKSPACE

Finding a workspace where you can keep your supplies together is part of getting organized. Few people are able to work as Violet did and take over the entire house for a few weeks with their scrapbook

The scrapbook brought back a lot of memories, but it was frustrating when things didn't have dates on them; a program would say Friday January 23 but not the year. Oh, it was very frustrating!

—V. B.

I have a box of wedding cards. I have this book I'm supposed to put them in, about six inches thick with cards. That's another thing I haven't done. There's too much to do. I'm working full time and there's no time.

—D. K. N.

supplies. Working on a dining room or kitchen table means that you will spend an inordinate amount of time taking things out and putting them away each time the table has to be used. If you have a dedicated workspace, a place to store albums, paper, scissors, glue, rulers, and whatever else you need for a long period of time, and a flat surface to work on, you will find scrapbooking much easier and more inviting. Shelves, boxes, plastic zippered bags, and baskets where you can store things but still have them readily accessible make it likely that your work sessions will be more productive. Whichever your method, getting organized is the first step to success in putting together your scrapbooks.

WEEDING THINGS OUT

What to keep and what to throw away is a perennial problem. Of course, everyone is different in this regard. Some people can make rigorous decisions because they know that they want to keep particular things; others have a hard time throwing anything away. One mother told me, "I've kept every scrap of paper the kids ever brought home from school!"

Reesa Devlin has a scrapbook for each of her three children, aged eleven, fourteen and sixteen. Each starts with baby pictures, a birth announcement, cards and photos, and moves into the school years. She is one of those people who keeps a folder for whatever the child brings home over the course of the year. At the end of each year she goes to work editing the pile.

> Of course I keep report cards, special achievements, end-of-year diplomas, pictures from field trips. And at the end of the year I pick things out, thinking in terms of twenty years from now—What would be a treasure to have? And the things that are really cute, that show their handwriting, or a special poem, or original artwork, I definitely will keep.

When I asked her how ruthless she is, Reesa said, "I wasn't ruthless before, but you can't accumulate everything. I might hang on to it for a year and then see how important it still is. As the children get

older, it's easier to be more objective about what you really want to keep. When they first come home with something they've just glued, how can you throw it in the garbage?"

The purpose of the scrapbooks for her children is to keep things for them in an organized manner. For the child who is a dancer, she keeps badges, reports, recital programs, tag numbers from competitions, adjudication, entries, pictures of her costumes. From a special birthday party are the invitations, pictures of an amazing ice cream sculpture, and cards from the child's friends. Every single page holds stories and memories.

EDITING

Whereas "weeding things out" is making decisions about what is important and what is unimportant, "editing" means deciding that an item may be important but that it isn't appropriate for your scrapbook. It may be an issue of privacy, or it may be that you don't want anything in your scrapbook that evokes a negative emotion.

For instance, what about letters that weren't addressed to you? Perhaps they are letters your parents exchanged during the war, or letters written by your father to his parents when he left home and struck out on his own for the first time. For some people, these are family treasures; for others, they should be thrown away unread because to read them would be an invasion of privacy.

Then there's the issue of editing after some time has passed and our lives have changed. For example, what do we do if a romance ends? Do we remove evidence of the relationship, or leave it in the scrapbook? As we have seen, Sara Jewell has kept scrapbooks for most of her life. She showed me a page of her high school scrapbook.

> This was a Greek guy I dated. I was on the track team for a few years and he was a javelin thrower. That's why these clippings of track events have his name underlined. I took all his pictures out of my photo albums, but I couldn't bear to rip up the scrapbooks. He's the only boy who ever made it into my scrapbook because he was in the paper a lot.

I think the main thing is that you are telling a story with pictures, so you have to be a bit ruthless in sorting through them.

—S. M.

Other than that, when I met guys in university they were never mentioned in the paper. I was lucky; I didn't have to deal with them in my scrapbook. And I'm mature now, so I can look through it and not worry about it.

So, I said, your scrapbook feels more permanent than your photo album?

It's permanent because it's your record. It would seem weird to edit your scrapbook and change who you were at that time.

from a scrapbook:
No one who has not been in the interior of a family, can say what the difficulties of any individual of that family may be.

—JANE AUSTEN

PERSPECTIVE

It's important to recognize that you will leave your own imprint on the scrapbook, even if you think you are compiling an objective record of events. Through the things you select, the things you leave out, and even how you place photographs, you are making a very personal book.

I learned this lesson when I was a student and hitchhiked through Europe for a summer. At a youth hostel in the gorgeous Austrian Alps I met a Canadian architecture student, and we decided to travel together through Austria for a week or so. Several months later we exchanged the photos we had each taken during that week. Lo and behold, his photos were all of windows, towers, and doorways, and mine were of people and mountains. For each of us they were our pictures from Austria, but you'd hardly know that we had been on the same trip.

The ironic thing is that if you are the person who takes most of the photos, you are unlikely to appear in many of them. So when planning a scrapbook that includes photographs, make sure that the camera is passed around so that some of the shots include you, particularly at occasions you want to remember.

Whatever your scrapbooking system, if you set clear goals and priorities for yourself, protect the time you need to accomplish them, divide the tasks into easily achievable smaller pieces, you will make good progress. Remember all those wonderful sayings:

"Rome wasn't built in a day," "a journey of a hundred miles begins with a single step," and the succinct Nike ad, "Just Do It!"

The very fact that you are looking at this book is a sign that you are on your way to making scrapbooks. Once you're convinced of the value of the activity, you will surely make time for it. If you have had experiences you want to remember, if you have things you want to preserve that fit into an album, or if you have the inclination to make your own book from scratch, then just have fun creating a scrapbook. The next chapters will give you some ideas about the specific kinds of scrapbooks you might consider.

PHOTOGRAPHY IN
THE SCRAPBOOK

Photographs play a central role in the modern scrapbook. Cameras are now very simple to use, and the choices in film and developing techniques can produce pictures that only professionals could think about a few years ago. A variety of mounting and cropping techniques can make even ordinary photos extraordinary. There are a few basic principles to keep in mind when taking pictures that you hope to put in your scrapbook or when choosing photos for your scrapbook.

When you are taking photographs keep in mind that you don't have to be a great photographer to take good pictures, and don't be afraid to take chances. Here are some tips that photographers use to get good shots, consistently.

1. *Keep it simple.*
 Get to know your camera and learn how to operate it. Learn the basics for taking the kinds of pictures you want. If you are ambitious or experienced, use a camera with more options, but there is nothing more frustrating than taking bad photographs and not knowing why. If you just want to point and shoot, use a camera that will allow you to do so.

 Simplicity is also essential to your photographs. Too much clutter will obscure the message of the shot. Think about the best angle to single out your subject or something to frame it to bring simplicity to your photograph.

2. *Identify your point of interest.*
 Once you have decided on your point of interest, try to emphasize it using some of the techniques listed below.

3. *Get up close to the thing or person you are photographing.*
 When you are trying to capture a shot, get up close to the subject, take a shot, and then get in even closer. Let your subject fill the frame. One word of caution: Don't take this approach with

wild animals, or with strangers without first getting their per-
mission to take their picture.

4. *Think about the shot you want and compose it.*
 - Use the rule of thirds (see page 108) to compose the picture.
 - Try to use informal or asymmetrical balance as it generally
 makes for a more pleasing composition.
 - Try to keep out elements you don't want, such as that overflow-
 ing garbage can to the left of Aunt Ellen at the family picnic, by
 moving yourself or Aunt Ellen, or by framing the shot so it can
 be cropped.
 - Place your subject where you want it (him or her).
 - Can you frame your subject? A frame is something in the fore-
 ground that leads the eye into the picture or gives a sense of
 where the viewer was.
 - If your subject can move, leave some space in front of it so it
 looks as though it were moving into, rather than out of, the pho-
 tograph.
 - Linear elements such as roads and fences are best on a diagonal
 rather than a horizontal angle.
 - Keep the horizon level.
 - Think about what it is you want your picture to say or the story
 you are trying to tell, and be picky about what you shoot. (This
 rule can be in conflict with Rule #7. With enough practice these
 steps should become somewhat automatic, leaving you free to
 catch those shots that catch your eye and are gone in an instant.)

5. *Pay attention to the light.*
 Usually you want the sun behind you, unless of course you want
 to achieve a silhouette effect. Think about which way the shad-
 ows are falling. Is your subject squinting, or lit up like a bonfire?
 Is the whole subject lit, or only part? It is best to avoid extremes
 of lighting as more often than not, they detract from a picture. If
 you are shooting indoors, avoid taking a shot against a window.

6. *Think about contrast.*
 A light subject looks better against a dark background and vice versa. Contrasting colors might also be used but be careful that they don't become confusing. If you are shooting outside try to avoid the mottled light of trees, glare from snow, and other extremes that detract from a picture. Taking pictures with black and white film is a great way to learn about getting good contrast.

7. *Take the picture, quick!*
 Don't dally when you see a great shot. Don't be afraid to waste a bit of film to get a great picture. Practice getting faster. You will be surprised what you can get on the fly.

CHOOSING PHOTOS

When you are choosing photos, pick the ones that are appropriate for your scrapbook. These can be wonderful shots accompanied by a story or a telling caption. They can be marginal shots that show the person or subject you want to remember or honor. If this is the case, and the pictures you have to use are not great but are the only ones available, you have several methods at your disposal to make them more attractive.

MOUNTING PHOTOS

A well-mounted photo on a scrapbook page always has more impact than one placed haphazardly. For good shots you can use archival photo edges to attach the picture to the scrapbook. Photo edges will not damage your picture and will allow you to remove it without difficulty.

Another technique for mounting photographs is to use a piece of paper behind them as a mat. You can cut out acid-free paper in a variety of shapes, colors, and sizes to place behind your photo to act as

a sort of frame. Using the same paper as the endpapers to frame a photo in a handmade book is very attractive and gives a cohesive look to a scrapbook. To make rough edges on handmade paper consider tearing them rather than cutting them.

Paper Mount with Frayed Edges

1. Lay a ruler on the edge you want to tear.

2. Take a paintbrush, wet it with water, and draw it lightly alongside the ruler to wet the edge of the paper.

3. Still holding the ruler along the tear edge, gently pull the paper at the wet line so that the fibers are pulled apart, leaving a rough edge.

Another option for a paper mount is to make a piece of paper specially to act as a mount behind a photo. (See page 185 for instructions for making paper.)

Remember that your paper mount can be angled behind the photograph or peek out behind a portion of it to call attention to the photo. The mount you choose should not overwhelm the photo.

CROPPING PHOTOS

If you are going to crop your photos make sure you have a copy or the negatives so that if you make a mistake you can have another print made. If you want to crop an old or valuable photo, make a color photocopy or have a print made and crop that. Never, under any circumstances, crop an original old or valuable photograph. When cropping a photo, make sure that you are emphasizing the image or point of interest. Cropping is a favorite activity in the new scrapbooking hobby. Scrapbooking stores, catalogs, books, and magazines offer a variety of templates and scissors that cut decora-

tive edges in a huge variety of shapes and designs. I like to keep my cropping techniques fairly simple so that the pictures will not look dated in a few years. I often crop around my subjects and lay their images on top of other images. You might also want to crop a series of photographs that go together to emphasize their connection. For instance, a series of landscapes can be cut so that the viewer can see a progression. Try laying out related photographs and seeing whether they would benefit from cropping to form a border on your page. Instant photographs cannot be cropped, so if you want to adjust one, make a color copy and crop that.

One interesting cropping technique is to take small sections of photos and cut them out to create small "stills." This involves cutting out square sections of interest and placing them on the page to give a feel for a time or place.

THE VALUE OF BLACK AND WHITES

Many scrapbookers like to work with black and white photographs. Why are black and whites still so popular when vibrant color film is actually less expensive to develop? One reason is that black and white photographs have a more timeless appearance than color photos. Even obviously modern photographs look classic in black and white. People often look more attractive in black and white. Also, black and white photos play up the graphic elements of an image, such as tone, line, shape, and contrast. It is easier to create a sense of drama on a scrapbook page with black and white photographs. I avoid mixing black and white and color photos on a page, but there are always exceptions to the rule.

HAND-TINTING

You can take color photocopies of your black and white photographs and hand-tint them using chalk pastels, oil pastels, photographic hand-coloring pens, felt-tip markers or color pencils.

EMULSION TRANSFER

This is a complicated and challenging technique for serious amateur photographers and dedicated scrapbookers. Emulsion transfer is a technique for placing the image from a photograph onto a piece of paper. Emulsion transfers have wonderful ragged edges and the images often end up looking much more interesting than the originals. Emulsion transfer can be very hit and miss and requires a great deal of patience. You also should be prepared to lose your Polaroid if the transfer goes awry. If you are still interested in trying it, here are the instructions.

To do an emulsion transfer you will need a Polaroid, lacquer or enamel spray paint, a piece of watercolor paper, a piece of glass at least as large as your piece of watercolor paper, two trays for water, a thermometer, a piece of wax paper, a squeegee, and a brayer (rubber roller).

1. Coat the back of a Polaroid print with lacquer or enamel spray paint and let it dry. This will prevent it from melting when it goes into the hot water.

2. Heat a tray of water to approximately 160°F and fill another tray with cold water.

3. Moisten your watercolor paper with room temperature water (hold it under a tap) for a few seconds.

4. Put the damp watercolor paper on the piece of glass and smooth it on with the squeegee.

5. Place the print right side up in the hot water for about 4 minutes.

6. Remove the print from the hot water and put it in the cold water bath.

7. Very gently, push the emulsion from the edges of the print toward the center.

8. Carefully lift the emulsion away from the paper backing, letting the emulsion sit floating in the water.

9. Throw away the paper backing.

10. Slide a piece of wax paper under the emulsion and using the corners of the image, lift it onto the wax paper.

11. Taking the image out of the water, flip the wax paper with the image attached so that it is right reading, and remove the wax paper.

12. Once again, put the wax paper under the image and lift the paper in and out of the water a few times to stretch the picture and get rid of any wrinkles.

13. When the image looks right to you, remove it from the water and put it on the watercolor paper, making sure that the wax paper is on top so the emulsion is touching the watercolor paper.

14. Rub the image onto the watercolor paper and very slowly and carefully remove the wax paper.

15. Smooth out the image as well as you can.

16. Roll over the transferred image with a brayer from the middle out to the edges, and hang the whole thing to dry.

17. When the paper and image are dry, spray them with a protective coating, available at art supply stores.

HINTS AND TIPS

Because emulsion transfer is such a laborious and tricky process, you want to make sure that it stays safe in your scrapbook. You may want to size the watercolor paper so that it becomes a whole scrapbook page rather than cutting it out and gluing it. Another way to protect your emulsion transfer is to place a piece of tissue paper between it and the next page. You can cut a piece of tissue the size of your scrapbook pages and bind it in with the rest. In fact, this is a good idea for any valuable photographic image or piece of artwork you put in your scrapbook. Good luck if you are brave enough to try emulsion transfer. Hopefully you will find that the results are worth all the work. For a beautiful example of emulsion transfer see Peggy Jessome's scrapbooks in the color section.

Journal
Scrapbooks

We have a need to chronicle the events of our lives, to create stories around the things that happen to us, and to document what we are thinking and feeling as we move through our lives. Memory and identity are closely linked, and we would quite literally lose our sense of personhood without the history and stories we have gathered on our journey through life. I often think that amnesia must be one of the most profoundly disturbing afflictions that can beset a human being. If we can't remember our past, who are we? When Don Mowatt lent me his scrapbook from childhood, he asked me to be careful with it and said, only half-jokingly, "If I don't have this book, I'll forget who I am!"

What do people keep in their journal scrapbooks that preserve treasured mementos and memories of their lives? There are as many answers to that question as there are people who keep journal scrapbooks, because each one is unique.

The urge to keep memorabilia is very strong, even though one might not have the time to put it into a scrapbook. Betty Dwyer has always kept some things in books such as pressed flowers, news clippings of the Queen's visit, travel brochures, tickets, maps from trips she made, and pictures of horses she used to ride and dogs

The book tells me who I am. I think of myself in the language of the scrapbook.

—D. M.

she's owned. She has kept programs of concerts and plays, sometimes accompanied by her own review and comments ("Paul Robeson was a wonderful Othello. He threw the most realistic fit I have ever seen. When he was told that his wife was unfaithful, he just got into a fury and fell down in this fit. That gorgeous voice just filled the whole theater."). But she also has boxes of letters she wrote to her parents between 1950 and 1980, mementos, club pins, brochures from every type of aircraft she traveled in (her husband was a pilot), and calendars which act as diaries of personal and family events for her. She has agendas from conferences she attended as a biometrician, and she has an entire scrapbook devoted to the track and field team that her son belonged to. And that's just for starters! So as she says, "These are wonderful books, because they combine the professional and the personal. They are the ongoing story of my life."

DIARIES AND SCRAPBOOKS

Diaries and journals have a long and illustrious history. They give the diarist the opportunity to understand and preserve his or her experiences by writing them down and giving them shape, and the satisfaction of being able to look back on these memories. Scrapbooks fulfill a similar function with some added flexibility. They permit us to use other people's words, ideas, and images to express our thoughts, experiences, and beliefs.

Victoria Miles bought a beautiful leather book on a trip to New York a few years ago. She let it sit for a year or so without entering anything into it. "I wanted to put something profound in it, but nothing came," she said. Victoria wrote a few pages, and becoming increasingly dissatisfied with what she had written, found herself pasting things into the journal, such as newspaper clippings, photos, ticket stubs, and a ribbon. And she found that her lovely diary was turning into something else. She recorded the transition:

So what began, awkwardly, as a journal has now revealed itself as a scrapbook. A good place to save what cannot be discarded from the re-

frigerator door. A place for people, where they matter, and always will. A place for sentiment and mirth and things that make sense to me at the time. This equals my scrapbook.

The scrapbook became a place Victoria put things that were tangible and visual—things she wanted to expand on and explain. She included a quotation by Princess Diana, whose death had a "bewildering" effect on her, a witty and meaningful piece by Kurt Vonnegut that she had been keeping on her fridge door, the business card and obituary of an admired colleague who died unexpectedly, and a saying from the wall of a Spanish restaurant that had struck her fancy: "Sometimes the Bull Wins!"

> These are things that would be discarded if there weren't some place to put them. The book really delights me now.

Similarly, Anita Boonstra explains why she finds scrapbooks more to her liking than standard journaling: "I tend to be more visual, as opposed to verbal. For me to sit and write would be laborious, it would be hard, and this is fun, because it is much more spatial and visual."

There is no rule about how much one should write in a scrapbook. Victoria enjoys writing, so her handwritten comments form an important part of her book. Anita writes in her books also, but not quite as much. Some scrapbooks are composed entirely of items that are found or clipped out of newspapers. But along with the clippings, photos, and memorabilia, many people who keep ongoing scrapbooks about their lives suggest keeping notes about the feelings, impressions, and stories that lie behind the objects.

A journal scrapbook is enjoyable to keep, and it reflects a great deal of the character of the creator through the particular selection of miscellany that it contains. It can be informal and flexible, permitting its owner to preserve a wide variety of meaningful items as long as they are fairly flat. What people find funny, moving, inspiring, or simply worth keeping speaks volumes about them. Many of the people I talked with called their books simply "My Life," and each scrapbook was as unique as the person who kept it.

From a scrapbook:
Inside the system I was treated very differently, as though I was an oddball and I felt I was an oddball, and so I thought I wasn't good enough. But now I think it's good to be an oddball, thank God, thank God, thank God!

—PRINCESS DIANA

PUBLIC OR PRIVATE?

People have varying reasons for making journal scrapbooks. For the most part, journal scrapbooks are quite personal, intended for their creator's eyes only. In my conversations with people in their seventies and eighties, I discovered that few of their grown children had seen their scrapbooks. These people felt that their children would not be interested.

This seems to be one of the fundamental differences between classic scrapbooking and the activity of making creative photo albums that so many people have become involved in during the past few years. Creative photo albums are intended to be shared with others, family as well as friends. Personal scrapbooks are kept much as a journal is, principally for the pleasure and satisfaction of the owner.

So the question to ask when beginning a journal scrapbook is, "Who is this for?" Sandy Goodall has four shelves filled with photo albums and scrapbooks. She made some of them specifically for her children, yet realizes that the children and their spouses are unlikely to want to take all of them when she gets older. "But I'm not doing it for them. Basically I'm doing it for my own pleasure. I love to do it. And all that stuff means something to me. Most of the stuff in the scrapbooks won't mean anything to the kids, except the things they were involved in. So I guess that's who you're doing it for. I'm just doing it because I enjoy it."

Some keep personal scrapbooks in addition to more traditional written journals, and have a different sense of whether they are private or for others to read.

Marie van Barneveld keeps her personal journal very separate from her scrapbooks. "The scrapbooks stay on my bookshelf in my living room. My journals are hidden far away." Ever since she was a child, she has used her personal scrapbooks to keep poems she liked, songs that meant something to her, stickers, and her own writing. There are some dried flowers: "This is from the winter I lived in Quebec City and on the May long weekend there was a major snowstorm and I had just gotten a letter from my mother with West Coast flowers in it. And I just cried. What was I doing in a snowstorm in Quebec when I could be home?"

My daughter had tons of scrapbooks when she was little, and tons of memorabilia. I asked her once to clear out her room, and she said, "My room is a museum to my childhood and to who I am." I think that's true.

—M. R. W.

Marie's sense of the importance of her scrapbooks is illustrated by this story:

> Once it got waterlogged, and I thought, Shall I throw it out, or keep it? And I decided to cut out what I could from the waterlogged pages. I re-did it, trying to keep as much of my handwriting at that time as possible. It absolutely cracks me up to see what I thought was important. Lots of songs I liked, but all through the book were these little cartoons called "Love is . . ." I guess I had a really romantic notion about love.

Like Marie, Sandra Moe keeps written journals that are very private, in addition to the more public scrapbooks. "I'm trying to decide what to do about my journals, which have been my inner thoughts, my inner struggles, my inner life. I'm not sure whether I'd want anyone else to read them. I guess it would depend on the attitude someone brought to them. If it was a historical questing attitude that's one thing. But if it's just for vicarious thrills, that's another."

Scrapbooks are generally not as intensely personal as written journals. Some people are motivated to make scrapbooks for others, and scrapbookers often talk about leaving a legacy for other members of their families. But for many, keeping a scrapbook is a way of documenting their own history, and whether or not anyone else ever sees it is beside the point. The satisfaction lies in creating it and having it for one's own personal reference and remembrances.

All of us, I think, edit what we choose to communicate. Certainly if you're keeping a scrapbook with the view that people will see it later, you're not going to put things that may reflect badly on you in there.

—B. T.

SCRAPBOOKING THE UPS AND DOWNS OF LIFE

It is always interesting to ask people what kinds of experiences they document in their scrapbook. Do they concentrate on the positive experiences only, such as celebrations, accomplishments, and high points? Or do they chart the course of their life, complete with the bumps, setbacks, and difficulties that each of us encounters? As one might expect, the answer depends on the character and personality of the scrapbooker.

One of the most eclectic scrapbooks that I have seen belongs to Anita Boonstra. She showed me the oversized scrapbook in which she recorded events of her life. On one page was a cheque stamped

"Insufficient Funds" and a speeding ticket. She explained why these weren't items destined for the waste paper basket.

> This is another first. It goes back quite a ways to when Ken and I were first dating. Meeting him really affected me! Here's what I wrote: "Got my first ticket and my first overdrawn cheque." My head must have been swimming. Of course the ticket was on the way down to Denver to meet Ken's folks. I was a little bit anxious. Good excuse. And the cheque was for ten dollars for the material for my wedding dress. I made my own wedding dress.

That explains everything. Anita added, "The story explains why I keep things. Sometimes you wonder why you kept something, but the writing helps explain it."

In the next pages were notes for the wedding plans, in her and Ken's writing, jotted down on the back of a placemat from a restaurant where they had lunch.

> It's about the ceremony as well as the details of who's going to do the flowers, the candles. Ken's shoes are on the list, but I don't remember why. There's a note to find out the first name of the minister who was going to perform the ceremony to put in the program. And then here's the invitation in its original envelope, the menu of the wedding dinner, and the honeymoon stuff; the Michigan hotel bill for twenty-seven dollars, a picture of the hotel we stayed at, a note about a great place for antiques, an ad from a candle factory, a placemat with a map of the area.

Other items in Anita's scrapbook include a newspaper article about one of her brothers who worked as a private investigator, a picture of the basketball team her sister played on, flowers in a cellophane envelope that Ken brought home from a mountain hike, an insignia from the front of a coffee bag from a coffee house they frequented, bank cards, a death certificate for their beloved dog, and an entire notebook of car mileage from a time when they wanted to keep track of gas expenditures. One of the oddest mementos is a broken key, taped onto a page with the story about it: "This is from the day we went to a wedding of some friends, and had a really good time, and

I guess I only put happy things in my scrapbooks so they just bring back great memories.

—S. G.

Ken tried to open someone's car trunk by mistake with our house key. You see the result!"

> All our bloopers are in here, a lot of first things, unique things, or silly things. Whether it's recording the planning process of a wedding, buying a car, whether to leave a job, it's all in here. I don't see this scrapbook as a collection of things, but rather a journey, a charting and following of my path in life. What I keep in here are all basically scraps, whether from a magazine or brochure, or notes I've written about an event or people, things that can be cut and pasted and whatever I feel can fit in a flat book. It's important now, because with all our moves and being frequently uprooted, even though the scrapbooks sit in the cupboards for a long time, they give me a better sense of what I've been through. It's really nice to have them.

Anita Boonstra is remarkably candid about recording the roads not taken as well as the roads taken in her life, the doubts as well as the certainties. But she stops short of recording real tragedies in the scrapbooks:

> The scrapbooks don't necessarily show depths of despair. In that way I'm selective. I don't know if I would put anything in here that was heartwrenching.

It is quite common for scrapbooks to focus on the positive. Sandy Goodall, having come through the terrible time around her breast cancer treatment, wants to remember the uplifting, the funny, the beautiful in her life. "I guess I only put happy things in my scrapbooks so they bring back great memories. Everything you see in a scrapbook is nearly always a good reminder, don't you think? Why would you keep things from a bad experience? Yes, the illness was a bad experience, but I think the good side of it is coming through it and carrying on."

As mentioned earlier, of the most important scrapbooks she has is of the many wonderful cards and letters she received while she was ill, letters she was emotionally unable to read at the time. She also has scrapbooks from the many hobbies she has taken up since

from a scrapbook:
The one thing that does not change is that at any time it appears that there have been 'great changes.'

—Marcel Proust

her recovery including astronomy, gardening, and above all, travel. I asked her the classic question: "If there were a fire, what would you try to save?" And she said, "I suppose my photographs. But my scrapbooks . . . now I'm going to keep them all in one place, and I'm going to take those out too! I see how very precious they are!"

USING SCRAPS, PHOTOS AND
SKETCHES TO TELL STORIES

There is a large area of overlap nowadays between scrapbooks and photo albums, and how you define your book just depends on your emphasis. Many people now include scraps in their photo albums, and probably just as many people include photos in their scrapbooks. The dividing line becomes very fuzzy.

Sandy Goodall has some interesting reflections on the value of scraps and the way they differ from photos to evoke memories:

> Looking through these scrapbooks brings back just a huge number of memories. In a way it's a different kind of memory than you have in a photo album, which is very specific to the people and the location. But this brochure from Garmisch, in Austria—when I look at it I remember the American serviceman who picked us up hitchhiking. He was a very nice person. I remember he was going golfing, but he stopped to give us a ride. I think scrapbooks complement photo albums; they are sort of the glue that tells the stories.

Barbara Shumiatcher keeps scrapbooks in which she does a great deal of sketching, and finds that the sketches are even more evocative than photos:

> I find that scrapbooks bring it all back so vividly, especially if there are sketches. Photographs don't quite so much. That's why I continue to sketch even though I'm no artist, because I can get hold of the feelings and keep them. I can recall the emotional tenor of the day or maybe the whole trip. It brings back the situation more vividly than words, and more vividly, for sure, than photographs. Photographs are a sort of addition. But the thing that makes me relive experiences and feelings is my own drawings, however bad.

I'm a storyteller. This scrapbook shows the different ways I've been doing that throughout my life.

—D. M.

The stories are what invest the scraps with meaning. Anita's broken key and speeding ticket, like Sandy's brochure from Garmisch and Barbara's sketches, mean nothing without the attendant story. And of course the artifacts act as memory jogs to bring the incidents, the people, the emotion of the original experience back to one's mind. With the passage of the years, many of these small anecdotes might easily slip away unless there is some reminder that is preserved in the scrapbook. That is why many people enjoy taking the time to write the stories that accompany the scraps, to ensure that they won't be forgotten.

The wonderful thing about scrapbooks is that no one can tell you that you are doing it wrong! Your scrapbook is yours to keep in whatever way you please, and whether you keep photos, journal entries, mementos, sketches, or a combination of things is entirely up to you.

OUR CHILDHOOD
SCRAPBOOKS

From the adults who talk with fondness about their childhood scrapbooks, I get the sense that these were children who enjoyed the process of making books of their activities and interests. Now, years later, the scrapbooks are poignant reminders for them of the people and circumstances of their early years, and connect them with the children they once were. A child's handwriting, the selection of items, and the care in putting the book together can be intensely moving to an adult.

Kerry Howard, the woman who delighted in her scrapbooks of horses, reminded me that there was no TV when she was growing up, so scrapbooking was a way to keep oneself occupied. As to whether she would show her book to other people: "I don't think anyone would have been the slightest bit interested!" She no longer has this scrapbook, just as she no longer has the journals she kept as a teenager, and she feels the loss keenly. "It was a lovely big fat book full of pressed corsages and added notes that I pasted into the journal. I'd give anything to have it back, just for the fun of remembering it all."

When I was fourteen or fifteen, and finally cleaning out the bedroom, my parents were nagging me about cleaning my room and the whole thing went in the garbage. I'm really sorry I threw it out. That was my first scrapbook.

—C. S.

This was my favorite activity when I came home from school. I'd kneel down on the living room floor with the magazines all around and LePage's glue for sticking in the pictures.

—L. S.

In today's world, children are faced with perhaps a wider array of activities to participate in, but keeping scrapbooks is still as important and satisfying as it ever was. It is a way of chronicling your adventures, preserving keepsakes, and demonstrating that you are an individual with your own sense of what is important in your life. The scrapbooks of some modern kids are discussed in Chapter 11.

Barbara Cook, the former New Zealander whose primary school scrapbook was made from the paper that fresh bread was sold in, lived on a sheep farm. Her family read magazines from England and received the *Auckland Weekly News,* with its glossy pictures in the middle. Her scrapbook has some pictures of scenes that would have been very familiar to her as well as pictures from exotic places, animals that she'd never seen, and famous people from around the world. She told me, looking at the book.

> We were very royal, so here are pictures of Edward VIII who abdicated. We were all monarchists so we cut out things that had to do with the royal family. Anything that happened in London was broadcast in the middle of the night in New Zealand, so many nights we sat up for weddings and funerals, with the stove going, listening to the radio. Now I look at this picture of Edward, and it brings back the incredulity. How could he do this, give up his country? And there was much tongue clucking and head wagging and it was a dark, sorrowful time.

And then, in her scrapbook are some sporting pages ("my father was a polo player") and a thermal page. What's a thermal page? "New Zealand is very volcanic, and in the center of the island we have a great thermal area of boiling mud, geysers, stalactites, caves, and these little bathhouses. These are what I used to go into when I was a little girl. And the warm water just bubbled up in the creek. This is a picture of the little meeting of roads where there was a gas pump and store and a little hotel, and hot springs. And now it's very glitzy with water slides and all sorts of things."

I asked Barbara what it meant to her to look at these pictures: "Certainly the scrapbook brings memories back. I'm sure I wouldn't think of the bathhouses without it. It brings back feelings of a happy childhood."

Don Mowatt also feels that his childhood scrapbook brings back memories. More than that, "The book tells me who I am. I think of myself in the language of the scrapbook." The scrapbook starts with an exchange of letters and a series of newspaper articles that tell the story of nine-year-old Donald winning a prestigious scholarship to study at a well-known preparatory school in Scotland in 1953. "The lad collects everything from stamps to seashells," wrote the reporter in one article. There are school reports, photos of friends and musical productions, letters. And through it all emerges a portrait of a young boy who rises to the challenge of this rigorous school with hard work (although sometimes "dreamy and distrait"), a good sense of humor, and particular musical gifts. "His position as leading violin is unassailable," wrote the headmaster, "and his playing in the competition has a distinctive polish and liveliness."

These threads of humor and musical ability have been consistent in Don's life, as one sees in his early scrapbook. They are evident in mementos from his childhood through to his university years when he participated in dramatic shows and developed a stand-up comedy routine, to his career as a radio drama and feature documentary producer and his involvement in musical performances. The comment from the article about the nine-year-old collector of "everything from stamps to seashells" struck a chord, because as Don says, "That's what I do as a documentary producer. I collect and I tell stories." When Don cautioned me to be careful with his scrapbook because it contained his whole life, I know what he meant.

A child's scrapbook tells the stories that the child wants to tell. This is not always the case when a parent keeps records for the child and perhaps unconsciously imposes his or her own perspective on what is important and worth remembering. For this reason, a child's scrapbook can be a most treasured item in later life.

At one point when my daughter was ten or twelve, she said she wanted a safe for Christmas, and I said, "Why a safe?" And she said, "So I can put my scrapbooks where nobody looks at them, especially you!" That's how important they were to her.

—M. R. W.

A TEENAGER'S SCRAPBOOK

The teen years, those tumultuous and intensely emotional times, are frequently documented in scrapbooks. As young people become aware of their uniqueness, their individuality, and the ways in which

they are similar and different from friends and family members, they often chronicle their lives in scrapbooks. If we are parents of teenagers it can be helpful to remember the joys and anxieties that surrounded our interactions with other people and the way we thought about our lives when we were teens.

Sandra Moe has memories of her bedroom as a teenager conjured by her scrapbooks.

> One of the things I know I did as an adolescent was to draw my room. I would draw the room at different times of the year, the room messy and the room clean. I remember doing this and feeling very good about it. I also remember finding some scrapbooks that an aunt of mine had kept which were movie star scrapbooks. They were very important because they were of a previous era and at the same time, because they were a life that was so removed from my own life, I saw them as a possibility for the future. I played a lot with paper dolls, and all my paper doll play revolved around a movie star kind of life, as seen through my aunt's scrapbooks.

As to the importance of having scrapbooks from her teen years, with their drawings and paper dolls, Sandra says, "They are literally a memory jolt. Often looking at my scrapbooks or photo albums is the only way I can reconstruct something from the past."

Dagmar Kaffanke-Nunn now lives and works in a large city. In 1967 she was a fifteen-year-old living in a small coastal mining town.

> I was a tall, gangly girl and did well in school, so I was somewhat isolated and didn't fit in with the in-crowd. They weren't interested in me, and I wasn't interested in them. It was probably just a defense mechanism on my part. But I was very interested in pop stars. I would buy popular magazines like *Sixteen* and *Hullabaloo* and just read them from cover to cover. Other kids would spend their allowance on chips and Coke but I saved all my allowance and bought 45 RPM records and magazines. I just lived a total fantasy life, I think.

Her scrapbook from that period has magazine clippings about stars,

From a scrapbook:
Teenagers, if you are tired of being hassled by unreasonable parents, now is the time for action. Leave home and pay your own way while you still know everything.

particularly the Beatles, and colorful psychedelic art inspired by the Haight-Ashbury counterculture style of lettering and design.

> You see these Beatle cards. You used to be able to get a package of that flat pink bubble gum and it always had three or four Beatles cards in it. And I collected hundreds of these things, and you know when you're a teenager, you're bored a lot of the time, at least I was. I spent a whole Saturday wallpapering a portion of my bedroom with Beatle cards. A whole wall, with the cards stuck on with Scotch tape. When my mom came in, she almost fainted. But she let me keep them.

I asked Dagmar what it was like to look at this book for the first time in many years. "I've never been one for nostalgia. I've always been more forward-thinking. In some ways the scrapbook kind of embarrasses me just a little bit. It's so childlike and so innocent. We thought we were cool, we thought we knew it all, but really it's a bit immature."

I think that's a fairly good description of what being fifteen is all about. But in a way, it is life-affirming to put yourself in touch with who you were at that age, to accept and to understand the reality of being a teenager. It is too easy in adulthood to forget those years.

from a scrapbook:
Every generation revolts against its fathers and makes friends with its grandparents

—LEWIS MUMFORD

SCRAPBOOKS FROM
YOUNG ADULTHOOD

After high school, young people's paths diverge and take the routes of first jobs, travel, or further education. Young adulthood is a time of change, of new experiences, sometimes of romance and adventure. A scrapbook kept during this period of life is an important reflection of the particular route taken. Whether it contains a letter offering you your first job, pay stubs and pictures of your co-workers, or mementos of your years at art school, a scrapbook from this period is a precious reminder of the beginning of your life as an adult.

A short time ago, Maxine Shaw went to the fifty-year reunion of her college graduating class. Three of the one hundred fifty people

This is a poem my friend wrote for me. Now something like this is a treasure you would never want to lose, but what happens to it usually is that it goes into a drawer and you never see it again.

—K. H.

attending brought scrapbooks along, and these were avidly examined by the others. Maxine's was one of them. I asked her what it was like to look at her scrapbook fifty years later.

> That's a good question, because a few years after I did it, I thought, "How silly, how petty." But as the years go by, every piece of paper is precious. They brought back memories for everyone.

Later, I asked Maxine if she would ever get rid of her scrapbooks, which she started making when she was ten years old, and has continued making throughout her life. She answered, "No, because these ring a bell inside me!"

Looking through her college scrapbook, I can understand why. There is a newspaper photo of Miss Maxine Johnson and Miss Elaine Roger, charter members of the newly established home economics department in 1943, her marks, and the Dean's letter (typewritten, not computer generated!) congratulating her on first class standing, a youth hostel card, clippings from the society page of the newspaper about people she knew, photos of handsome young men in military uniforms, a handwritten letter in its original envelope inviting her to join a sorority, programs of musical and dramatic productions, mementos from dates, ribbons from the college sports teams, and articles about friends' activities.

There is also a full-page picture of two young women putting on roller skates, with the headline "Kids' stuff but it gets you there." The caption reads: "It's been a long trek for Maxine Johnson and Audrey Creese but they made it to their classes at the university despite the streetcar strike. Of course they're so exhausted they don't know whether they'll be able to absorb much learning or not. But they're still not quite so exhausted as some of their little schoolmates who had to hoof it all the way without the benefit of roller skates." Maxine told me the story behind this article was that the journalist brought the roller skates himself, and asked the girls to put them on. Obviously the phenomenon of journalists creating, rather than reporting, news has some history!

One of the defining aspects of Maxine's college years was World War II, and so there is a sober aspect to the scrapbook as well as the

fun. Christmas cards from boyfriends overseas, an obituary of a high school friend who was killed, French francs in an envelope, newspaper articles, all paint a portrait of a time of uncertainty and dislocation.

> That's a mix of emotions. We did learn how to make do, how to manage without material things. But there was also the loss of friends, those young boys. Out of a class of ten in high school, three of the young men were killed. We didn't really realize that it was forever. You just don't at that age.

Young adult years are when people become aware of the possibilities that life offers, and aware of the choices that can be made. At the same time, one's path in life is sometimes influenced by outside forces, by politics and economics. A scrapbook kept during those formative years evokes young adulthood in all its complexity.

SCRAPBOOK OF
FAMILY LIFE

Scrapbooks kept during high school and college years chart the journey of a young person coming into his or her own. Marriage and family are the beginning of another chapter, during which one's life becomes intertwined with that of others. In many cases, the focus shifts from the thoughts and feelings of the scrapbooker to the activities of their children. Often people are just too busy with family life to make any kind of record of early family life.

For many people, making scrapbooks takes on another function: that of keeping a record of family life for the next generation. The experiences of some of these people will be discussed in the next chapter. But there are also many people who, even at this stage in their lives, keep a personal scrapbook primarily for themselves.

Barbara Cook is one of those people. The scrapbooks she kept as a child and a young adult flowed quite naturally into a chronicle of her life after she was married and had children. They include mementos from her working life and "packets of things" from the children as they grew up: cards and handmade gifts that would fit into

Looking at these scrapbooks brings back those years of nonsense and fun and stories, and a sort of liberation for me. These just pour it back into my mind.

—B. C.

I come from a long line
of scrapbookers.

—S. J.

the scrapbook, letters to them from her own mother, and some of their drawings,

Kerry Howard is also an inveterate saver, and her scrapbooks are filled with aphorisms and poems that are meaningful to her as well as mementos from her life as a wife and mother. She said:

> I was very pleased I saved it all, because so many people don't. This is a thank-you note from a friend, with a lovely poem, and this is a poem Dick's mom wrote for him on his birthday. There are newspaper columns that I really liked, and lots of sayings, because I love quotations. I have everything my kids ever drew in school, every card they ever sent me, all the report cards, even Rob's baseball cap from when he was in Little League.

Kerry is a grandmother now, and has ongoing scrapbooks that include her grandchildren's artwork.

> When they visit and draw a picture, it starts out on the fridge, and I think, "I've got to save this," so they're all going in the scrapbook. I guess the secret is to have one spot where you put things!

For Anita Boonstra, the birth of her children just gave her more scope for her scrapbooks.

> When Erin was born, someone gave me an ad with a picture of a baby that looked just like her. I thought that was really cool, so I kept it. Here is the death certificate for our dog. Here I've written, "These were times of good-byes," because that was when we moved. This is a Father's Day card Erin made; I've kept all the handmade cards of the children, and swimming badges, and valentines, and souvenirs from places we went together. I'm not sure with the kids how much I want to take over their events. Erin just in the last year insisted I buy her a school organizer where there are pockets and space to write in. So when she wants to do her own scrapbook, that's up to her.

CONCLUSION

It is extremely difficult to generalize about the types of personal scrapbooks that people keep about their lives. Each person's life has followed a unique path, with its own joys, sorrows, accomplishments, dreams, and challenges. When one documents this path as one is following it, it fulfills a basic need to hold on to experiences and thoughts. Making a scrapbook is creative and satisfying, and looking at it years afterwards helps bring the stories back to mind. No matter what one chooses to put in a scrapbook—photos, journal entries, news clippings, sketches, or memorabilia ranging from pressed flowers to luggage tags—the book is a priceless and personal account of one's life. In Marie van Barneveld's words:

> It's about me, it's about who I am, it's about where I've been and where I've come from, and the steps I've made.

Whether you keep personal scrapbooks at one particular stage of life, or as an ongoing record much like a journal, or from time to time throughout your life, you will find joy and satisfaction in the process as well as the product. The scrapbook is a reflection of who you are, how you live your life, and what is important to you.

Project Three

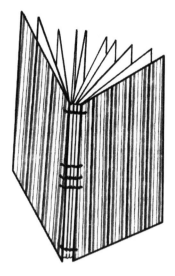

Making a Stitched-Back Scrapbook

This scrapbook is bound using a stitch known to bookmakers as a "coptic stitch." The exposed stitching on the spine makes for an attractive and earthy-looking scrapbook. Remember that this binding cannot be undone at will so plan your pages carefully before pasting things into the book. I like to make pocket pages (see page 189 for instructions) and glue envelopes into the signature (or folded) pages before I bind it.

To make a stitched-back scrapbook you will need:
Inside paper

You will need at least twenty to forty sheets of paper that when folded in half are the desired size for your scrapbook. Use twenty sheets if you are using a very heavy paper and forty if the paper is a lighter weight.

Cover boards

Cut two cover boards ¹/₂" longer and wider than the folded sheets of paper.

Cover paper

You will need two sheets of cover paper 1" longer and wider than the cover boards.

Endpaper

Cut two sheets of endpaper the same dimensions as the inside paper.

Thread

You will need a heavy waxed thread. You can find this at book binders' supply companies, or at any marine supply store or store that supplies net making materials (where it is called "whipping twine"). Another option, if you cannot find proper waxed thread, is to use heavy linen thread or some other type of thick thread that won't stretch.

A piece of cardboard 2" wide and the same height as the pages for a jig

Paste or glue

Bone folder

Needle with an eye large enough to accommodate your thread

Awl

Pencil

Ruler

Utility knife

Scissors

Book press or heavy weight large enough to press your covers as they dry

FIGURE 3-1

FIGURE 3-2

FIGURE 3-3

METHOD

1. Divide your inside paper into stacks of five to ten sheets and fold them in half. You should end up with four signatures (or sets of folded paper) (Figure 3-1).

2. Glue your cover paper to the cover boards using a corner that suits your cover paper (see page xx for a full description of corner options). Put them under a press or a weight and let them dry.

3. Fold the two endpapers in half (like the inside papers) and glue them onto the cover boards. Remember that the endpapers should be aligned with the back of the book so that they match the signatures. Press the cover with the endpaper attached under a weight, leaving the free half of the endpaper outside (Figure 3-2). Do not press the loose part of the endpaper with the cover board as often the moisture from the glue will warp the paper.

3. While the covers are drying, make a jig to measure out the holes for sewing. Crease the jig cardboard in half down the middle, and use it to mark the holes with a pencil inside the signatures. Then use it as a cradle as you punch the holes from the inside out along the crease of the signatures. You can place the holes anywhere you like along the spine but I recommend placing one set of holes 3/4" from the top and bottom of the spine and the rest of the holes no more than 2" apart (Figure 3-3).

FIGURE 3-4

4. Take the dry covers and with the endpapers laid out flat, place the jig 1/4" from the top and bottom of the covers and punch holes to match those in the signatures.

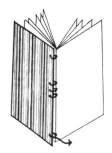

FIGURE 3-5

6. Take a piece of thread at least four times as long as the height of the book and thread it through your needle.

7. Begin by sewing through the top hole of the first signature from the inside (Figure 3-4). Sew out through the top hole of the back cover. When you have sewn through the back cover, sew through the hole on the endpaper and thread the needle back through the top hole of the signature, and tie it closed inside the signature.

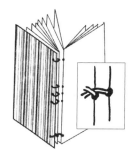

FIGURE 3-6

8. Sew down to the next hole and back around the cover, and continue this until you reach the bottom hole (Figure 3-5).

9. Once you reach the bottom, sew out the first signature and around the back cover and then instead of sewing back into the first signature, sew into a second signature, catching the stitch as you go (Figure 3-6).

10. Thread the needle up to the next hole and out. Then catch the stitches that lead into the back cover (Figure 3-7) and sew back into the same hole and up.

11. Continue this process until all but one of the signatures have been attached. When you reach the last signature sew under the last stitch and with that same stitch, sew through the front cover from the outside to the inside. Sew all the way up into the final signature in this way and tie off the last stitch inside the signature (Figure 3-8).

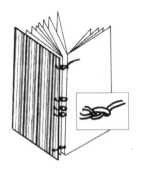

FIGURE 3-7

FIGURE 3-8

HINTS AND TIPS

If you look at the stitching on the spine of your book and discover that you have missed a stitch somewhere, you can fake it by sewing back through the same holes with extra thread to catch the missed thread. Few people will be able to tell and the extra thread inside the book shouldn't make a difference in bulk, and it is much simpler than having to resew the entire book!

DRYING AND PRESSING FLOWERS
FOR YOUR SCRAPBOOK

To press flowers and leaves for your scrapbook you can buy a ready-made flower press from a hobby shop, or you can make your own using two sheets of heavy-duty plywood (at least 8 1/2" by 11"). Use C-clamps large enough to press the two boards together with several sheets of paper between them.

It's best to gather flowers on a dry day and put them in your press as soon as possible. Put them in a plastic bag if you can't get them pressed right away. You will want to choose flowers that will not be crushed and distorted in the press, and stay away from those with very thick stems and leaves. For larger flowers, consider thinning some of the petals or drying the petals individually. Place the flowers and leaves between two sheets of thick paper and place the sheets in the flower press. Each layer of sheets should have a thick piece of cardboard between it and the next layer of sheets. Check the flowers after ten days to see if they are dried. They may take more or less time, depending on the types of flowers and how many you are drying.

If you are just drying a few small flowers you can place them between the leaves of a heavy book (between two pieces of heavy paper to avoid staining the pages).

Glue your flowers to your scrapbook pages to commemorate an event or to act as a border or page accent. You can also glue them to the cover for a decoration or use them to découpage a scrapbox.

If you need your pressed flowers in a hurry place them in an old book (not a valuable one) that is at least two inches thick and has no metal edges or gilded pages. Put your flowers between the pages and stretch an elastic band around the book. Heat the book on medium for 2 to 3 minutes.

HELPFUL HINTS

Don't let your dried flowers touch your photographs and be aware that they may yellow the page they are attached to.

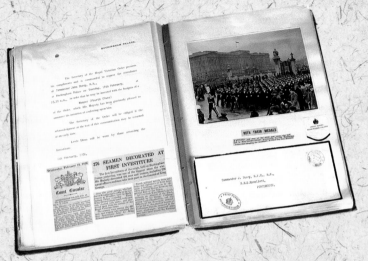

*This scrapbook is both personal
and political. Created in the turbulent
years of WWII, the book is also
a son's lasting connection
with his father.*

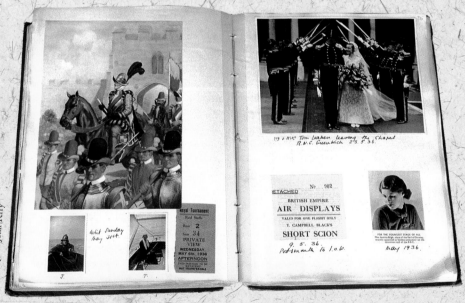

by Captain John Terry

SCRAPBOOK PAGES

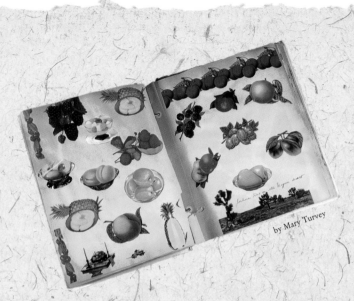

Created by a loving grand-
mother for her grandchildren
as a book for show and tell,
this 50-year old scrapbook is
part of a family history.

by Mary Turvey

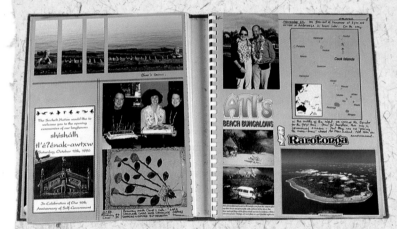

These scrapbook pages
commemorate a trip.
The photo cropping techniques
show how photos, maps, and
other memorabilia can be
combined for intriguing effect.

To compare
two generations
of scrapbooks, see the
creator's fathers'
WWII scrapbook.

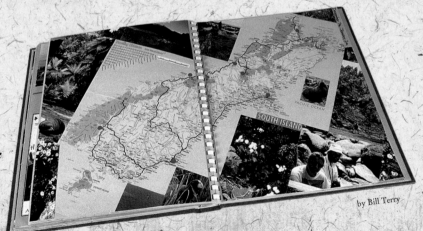

by Bill Terry

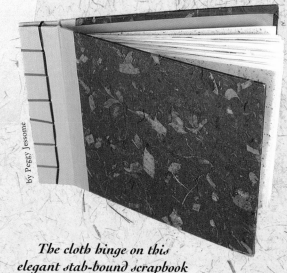

by Susan McDiarmid

by Peggy Jessome

This raffia-bound scrapbook with pressed flower paper covering is the perfect gift for a wedding or baby shower.

The cloth hinge on this elegant stab-bound scrapbook makes it strong and durable, as well as beautiful.

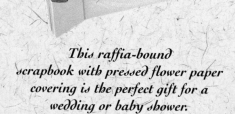

Let your peekaboo window be the introduction to your scrapbook. Japanese corrugated paper and gold-flecked paper frame a delicate dried flower.

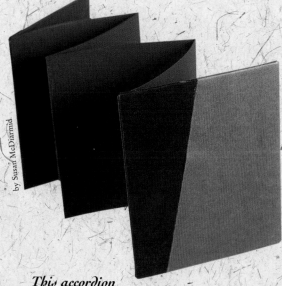

by Susan McDiarmid

This accordion scrapbook is an ideal choice for mounting photos and other memorabilia with its finely textured black pages, and cloth and paper covering.

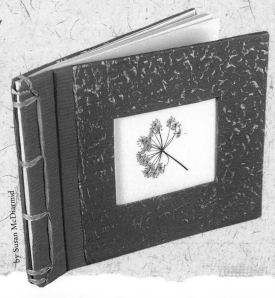

by Susan McDiarmid

ROMANTIC SCRAPBOOKS

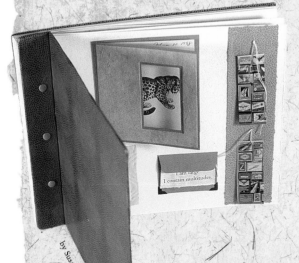

by Susan McDiarmid

Orange lizard-skin textured paper cover, japanese glitter endpaper, and torn-edged watercolor pages make this oversized scrapbook an eye-catcher. Created as a romantic scrapbook, the pages are filled with quotes, shared jokes, keepsakes from special dates and mementos from a fishing trip.

Inside the envelopes are printouts of treasured e-mails and cards. Labels from gifts of cookies and candies are attached with string. Pages are given interest with decorative paper mounts and odd memorabilia is sewn into a slide protector sheet.

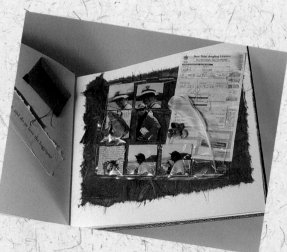

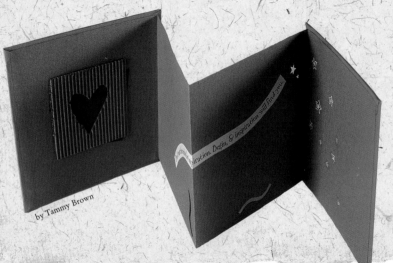

by Tammy Brown

This wonderfully understated accordion scrapbook uses cutouts for borders and a collage to convey its message.

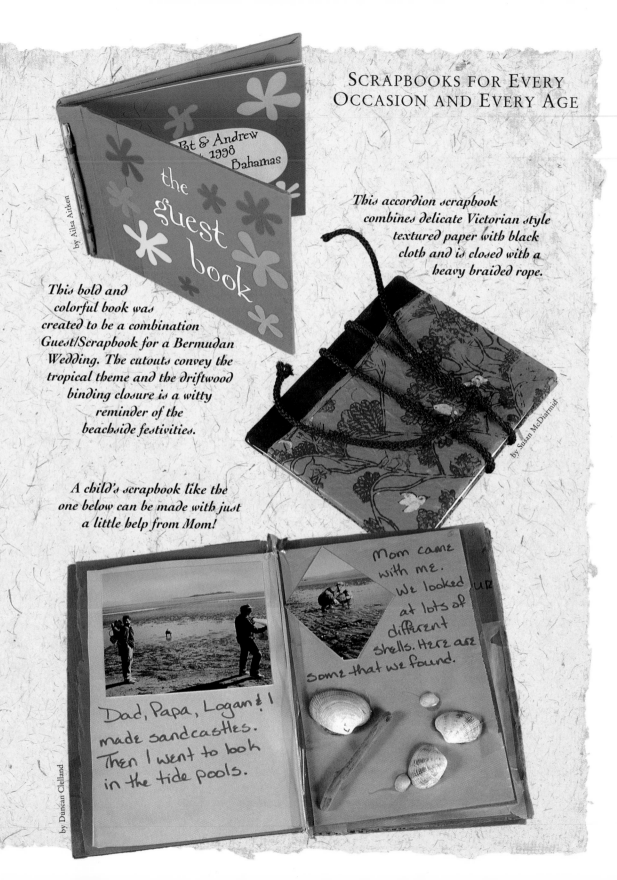

by Ailsa Aitken

Pat & Andrew
1998
Bahamas

the
guest
book

This accordion scrapbook
combines delicate Victorian style
textured paper with black
cloth and is closed with a
heavy braided rope.

This bold and
colorful book was
created to be a combination
Guest/Scrapbook for a Bermudan
Wedding. The cutouts convey the
tropical theme and the driftwood
binding closure is a witty
reminder of the
beachside festivities.

by Susan McDiarmid

A child's scrapbook like the
one below can be made with just
a little help from Mom!

Mom came
with me.
We looked
at lots of
different
shells. Here are
some that we found.

Dad, Papa, Logan & I
made sandcastles.
Then I went to look
in the tide pools.

by Duncan Clelland

SCRAPBOOKS PROJECTS WITH A TWIST

This découpaged dried flower scrapbox with a raffia woven lid will come in handy for those oddball treasures you just can't bear to part with.

by Susan McDiarmid

This reversible sewn scrapbook holds a collection of natural objects gathered on a memorable hike in the mountains.

by Susan McDiarmid

A dragonfly attached to the cover, an autumnal leaf protected with waxed paper, and bits of colored decorative paper preserve the beauty of the day.

B

by Edward R. Turner

The secret scrapbox is a fun and charming way to keep the memorabilia that won't fit in your scrapbook. Your kids will love it!

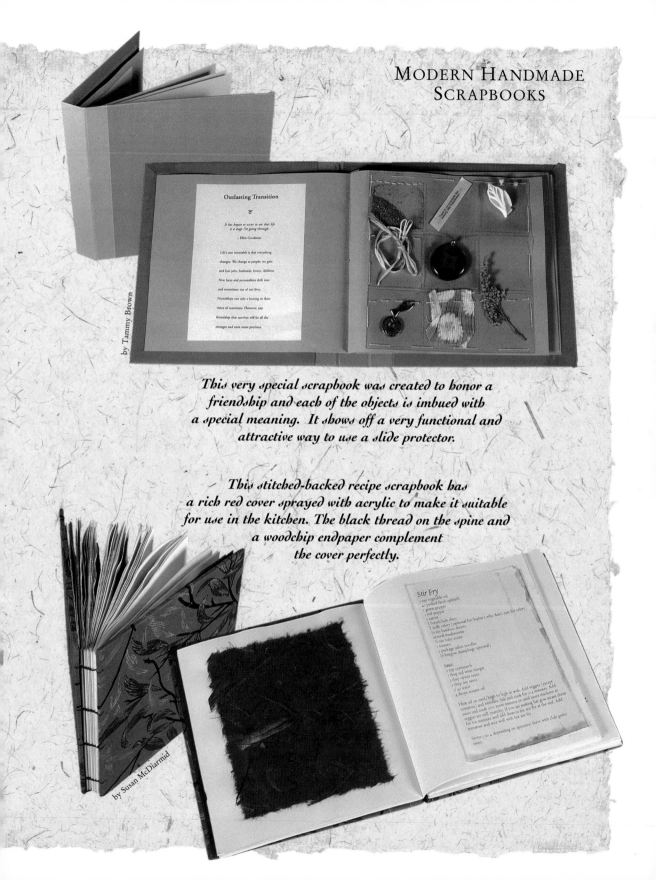

by Tammy Brown

This very special scrapbook was created to honor a friendship and each of the objects is imbued with a special meaning. It shows off a very functional and attractive way to use a slide protector.

This stitched-backed recipe scrapbook has a rich red cover sprayed with acrylic to make it suitable for use in the kitchen. The black thread on the spine and a woodchip endpaper complement the cover perfectly.

by Susan McDiarmid

A Modern Classic Scrapbook

by Peggy Jessome

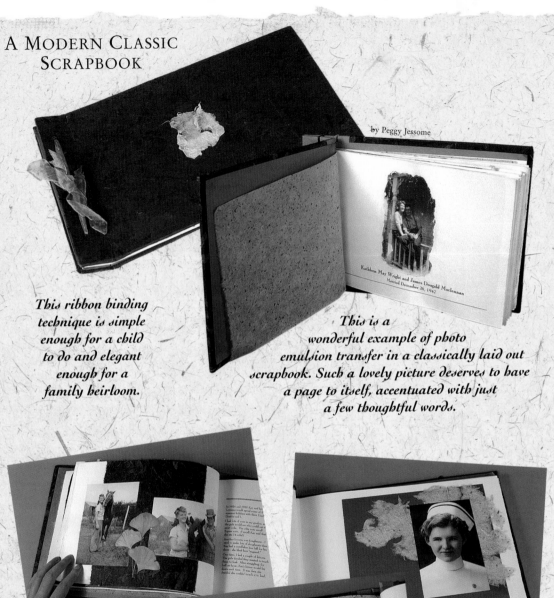

This ribbon binding technique is simple enough for a child to do and elegant enough for a family heirloom.

This is a wonderful example of photo emulsion transfer in a classically laid out scrapbook. Such a lovely picture deserves to have a page to itself, accentuated with just a few thoughtful words.

Kathleen May Wright and James Dougald Maclennan
Married December 20, 1947

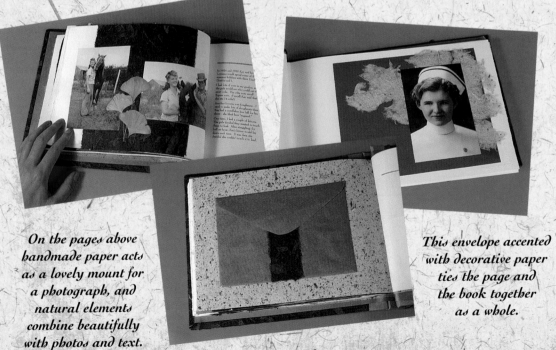

On the pages above handmade paper acts as a lovely mount for a photograph, and natural elements combine beautifully with photos and text.

This envelope accented with decorative paper ties the page and the book together as a whole.

Chapter Five

Chronicles for Future Generations

Many people begin scrapbooks as a legacy for future generations of the family, recording events in the family's life for others and not just themselves. The idea of writing memoirs can be daunting, but personal history scrapbooks may provide an easy alternative. In contrast to journal scrapbooks, they can be created with the enjoyable benefit of hindsight and time for reflection. Relationships that didn't work out, plans that didn't quite develop as they were meant to, paths that weren't followed, may simply be omitted. In general, although this is not always the case, legacy scrapbooks highlight the positive experiences and relationships in one's life.

In this discussion of legacy scrapbooks I will include scrapbooks that are made by parents for their children, either while they are growing up or afterwards. We will see that it is never too late to start a scrapbook of the significant events of your child's early years.

THE LEGACY OF A PERSONAL
HISTORY SCRAPBOOK

One of the valuable aspects of a personal history scrapbook is the perspective that one brings to it. I wrote in an earlier chapter about

When our first grand-
daughter was born, I
began to keep scrap-
books and journals. My
husband and I realized
that so many things
that characterized our
childhood would be
completely strange to
our kids, never mind
our grandchildren. So
that's when I started
recording a little bit.

—B. S.

the scrapbooks made by Elizabeth Campbell's grandmother, Mary Turvey. One was created as a memoir scrapbook, a compilation of the poems, aphorisms, articles, and photos that she had kept over the years because they were meaningful to her. It's very personal, and Elizabeth feels that it captures more about Mary than the carefully constructed written account of her life which she did as well. Her grandmother's scrapbook paints a portrait of a woman who valued hard work, who admired people of accomplishment, who was more than just a little bit feisty, and who loved her home and her family beyond words. One of Elizabeth's favorite pages contains a clipping of a poem by Helen Roger Smith that reads in part:

> I do not ask that all my days be fair with cloudless skies,
> But for the courage to stand firm when stress and storms arise.

Underneath, Mary Turvey wrote in parentheses, "I have tried!" and under that her son Jack wrote after her death, "I believe everyone who knew her would say, 'Well done, Mary.'" So this scrapbook became a sort of interactive, intergenerational book about one remarkable individual.

At age seventy, Violet Burgess spent several weeks creating twenty-five albums from the boxes of memorabilia she had been keeping. When I asked her if she has a favorite item in her books, she answered, "As the years go by, it's the old stuff that I like, because I can sit and tell my grandchildren what things were like when I was young. I can tell stories."

Violet told me that the scrapbook helps her to remember things she would otherwise forget and to bring back the emotion of times she will always remember. No one who lived through the Second World War could forget the feeling of watching young men going off to war.

> Here's a real famous picture. It's of a little boy running after his dad as his dad is marching off to war. Before I was married I worked as a telephone operator. And then after I was married I worked at a ladies' dress shop. Before they sent the men overseas they'd always parade them down Hastings Street, right by the dress shop, and it was always quite

emotional. This fellow, I went to school with him in Grade five. These were four brothers; two of them didn't come back. This was my first boyfriend; he went off to war, and I had to write him a "Dear John" letter when I met Lyle. He has since passed away.

There's a picture of Violet and her new husband, Lyle, in his naval uniform, and a caption reading, "Starting out on the road of life together." There's the wedding announcement, the wedding invitation, congratulatory telegrams, letters accepting the invitation to attend the wedding, and the wedding cards.

And then the babies started to arrive. Baby shower cards, lots of anniversary cards, and a baby book started for the eldest son, but Violet soon was too busy to continue. There were six children in all, so there are a great many children's birthday cards, and small things in childish printing that the children brought home. There are also literally scraps of paper that Violet felt were touching or funny or simply worth keeping, such as a little note written by the ten-year-old girl next door who loved to play school. Her "pupils" were the Burgess children, and she wrote the following report card: "Dear Mrs. Burgess, Cathy is behind in her school work. Ricky is ahead of her. She will catch up though. In fact, I think she's there now. Do not worry." And there is the note that one of her sons once left for her: "I'm going on a hike. Please make me a tuna fish sandwich. Can I please have an apple, grame [sic] wafers and a sucker? I'll get a packsack. Rob, Wayne and me are going down to the train tracks and hike along them." There are flyers from church activities the children attended, and every letter that they wrote to her, as well as postcards and greeting cards from friends. Each and every item in her books holds a memory from Violet's personal or family life.

LEGACY SCRAPBOOKS IN THE
CONTEXT OF WORLD EVENTS

Each scrapbooker will include a different balance of personal items and items that reflect the social or political climate of the times. Many people, like Violet Burgess, who lived through the Second

Our grandchildren might be interested to know our thoughts and feelings, and they'll of course be interested to see the chronicle of their own lives as seen through their grandparents' eyes. That's one of the most important aspects. I feel we're sort of the keeper of those times.

—B. S.

World War, include clippings, poems, and memorabilia from the war in their scrapbooks. It would be hard to keep one's personal life entirely separate from what was going on at the time in the world.

A set of two truly remarkable consecutive scrapbooks belongs to Bill Terry. They were created meticulously from 1934–1946 by his father, John Terry, a captain in the British navy. They are a family chronicle, to a degree, and contain some family photos, many theater programs, birth announcements of the children, and a drawing by four-year-old Bill (predictably of a naval ship). But they also incorporate a lot of historic events, including some fairly valuable documents. Bill showed me the first scrapbook which started with the marriage of John and Theophila Terry.

> All the stuff at the beginning is about their wedding. Her blue garter is pinned to the page, together with an 8 by 10 fading black and white photo of the bride with her bouquet. Since my father was a naval officer, they had the traditional column of raised swords, and little page boys all decked out in naval uniforms. It was a small village in Cornwall, so it was a fairly momentous event, well written up in the newspapers.
>
> And there is a lot of naval stuff, as well as invitations to society events, clippings indicating various places they stayed, letterhead of hotels they stayed in. Here's stuff from a holiday in Norway with a ptarmigan feather stuck in. And clippings from the time my mother knocked over a bus and never drove again.

I beg your pardon?

> The first time she drove, in 1934, she actually knocked a bus into a ditch. Happily nobody was injured. So here's the clipping from the local paper and the summons she received. She was fined four pounds with twenty-eight shillings cost.

Bill flipped past some signed pictures of the Duke of Kent and his wife, Princess Marina of Greece, that were taken on the occasion of their wedding in 1934, as well as souvenir menus from the royal wedding dinner. He then showed me the colorful printed program

of the jubilee celebration of King George V in 1935, and pointed out a note of thanks his father received from the Prince of Wales for his contribution to King George's Jubilee Trust. It is signed simply "Edward P."

> And then we get into the death of King George. Here's a wonderful big poster, folded in four, which is the proclamation "that the High and Mighty Prince Edward Albert Christian George Andrew Patrick David is now, by the Death of our late Sovereign of Happy Memory, become our only lawful and rightful Liege Lord Edward the Eighth." And here is the picture of King George's funeral procession, with the naval ratings towing the gun carriage with the coffin on it. This is the armband that my father wore; he was a lieutenant commander and he was the officer in charge of this group of ratings. There he is in the picture, arriving at Windsor Castle. It's all very ceremonial. And here's an envelope addressed to him, no stamp, postmarked London, Privy Purse, Buckingham Palace, black edged, in which he was commanded to Buckingham Palace in order to be invested with the "Insignia of a Member (Fourth Class) which His Majesty has been graciously pleased to announce his intention of conferring on him." He actually got a medal for that job.

The second large scrapbook begins with the events leading up to the war; many of the identifying captions are in Bill's mother's handwriting, as she kept the scrapbook while her husband was at sea. Bill turned the pages containing news clippings of Chamberlain reading the pact he signed with Hitler. Mixed with news of the war were more personal mementos from John Terry's life in the form of letters, photos, obituaries of people he knew, Christmas cards from friends, pictures and souvenirs from holidays with his family as well as from theatre and concert performances. And among the notes and clippings is the news release that John Terry was promoted from commander to captain.

> Towards the end of the war there are some quite interesting documents. Here's a communiqué dated May 2, 1945 from the commander in chief, Mediterranean. It's the actual document sent to my father as

Looking at the scrapbook from the war years brings a mixture of sad and happy memories. We learned how to make do, how to manage without material things. But there was also the loss of friends, all those young boys.

—M. S.

During the war I worked at Boeing in the summer. I was a rivet bucker. I'd hold a piece of metal and the girl on the other side of the airplane part would push in with a drill and I would hold the piece of metal to put resistance. These are the pay stubs from that time, and here's a newsletter from the company.

—M. S.

captain of his ship instructing him to cease immediately any hostile action. It describes the time of the surrender and says all ships and submarines are to return to their normal base and remain there. It probably came in Morse code.

And then there are the citations that he received after the war. The president of the United States approved the award of the Legion of Merit to my father, and the citation is signed by James Forestall who was secretary of the Navy and Franklin Roosevelt as commander in chief. His ship did some very daring stuff in assisting the American landings in the south of France. It describes how "operating in total darkness, within perilously close range of hostile shore artillery, Captain Terry conducted accurate and vigorous bombardment of batteries and troop concentrations . . . and, by his bold and daring tactics, succeeded in effecting the neutralization of enemy strongpoints."

Bill Terry told me that growing up, he was not very interested in the scrapbooks, but they mean much more to him now. "As you get older, you appreciate the value of it in a number of respects. The value in its literal terms — there's some important and interesting stuff in here. But also the value of its being one of the few connections I have with parents who I didn't really know a great deal about. I don't necessarily know my parents better from reading this, but I know what they did, how they lived."

There is, however, one characteristic of his father that is reflected in almost all photographs.

He always wore his hat at a rakish angle. Now this does say something about him, because he was that kind of a guy; he liked the society of ladies, and he was a bit of a flirt, I think. Whereas all the other naval officers in these pictures have their hats on quite squarely, there's my father with his hat tilted down towards his left eye."

Not surprisingly, Bill keeps scrapbooks of his own life and family.

Inevitably, because there isn't a war on, it's much more reflective of family activities. I sometimes include in my books a reflection of major events which seem to be big in our lives at the time. For example, the blowing up of the *Challenger* is there. Why, I don't know, it just had a

very dramatic impact on me. . . . But there is a tremendous amount of family stuff, masses of photographs of children and grandchildren. You will find reflected the travels we've been on. You will find the theaters and events we've been to. And my passion for gardening is reflected here.

I think that both these books and my parents' books are designed for others to read later. I am doing this, and I think my parents did too, for the next generation. Because you want to lay out something of your life, in some place. We're not all wonderful writers, and we don't have the resources or the means to do an autobiography. But this is in a way a kind of autobiography. For the grandchildren, this will be a very rich source.

PRESERVING THE STORIES BEHIND
PHOTOS AND SCRAPBOOK MEMORABILIA

We all know how important it is to identify people in photographs; anyone who has had to sort through a box of unmarked photos will attest to that. But it is also valuable to make a few notes about the circumstances of the photo, the significance and mood of the event, the impressions of the landscape, and the reasons for remembering that particular moment in time to give resonance for future readers.

Similarly, when you keep a ticket to a play or concert, or a luggage tag and travel brochure, or a piece of hotel stationery, that object will have particular significance for you because it is a reminder of a particular event, but your children aren't mind readers! If you are making a scrapbook with an eye to the future, no one will understand that significance unless you write a few lines of explanation.

KEEPING SCRAPBOOKS
FOR GRANDCHILDREN

Several people expressed the view that they were keeping records primarily for grandchildren. Parents are often too busy raising families and having careers to document their lives, but grandparents may have a little more time in which to do so.

I went through a long period of time when the kids were growing up that I saved everything in boxes. Things they made themselves, gifts and things, I saved them all but was just too busy to put them in scrapbooks. Then after I got sick I just realized that I had an attic full of great stuff, and I'd better get going and try to get things organized.

—S. G.

Barbara Shumiatcher made a conscious decision when her first grandchild was born to begin to keep a record of her own experiences and thoughts for her granddaughter.

It's got photographs, sketches, and especially sketches about feelings. There's a sketch of us flying because those were our feelings when we heard she was born. We were so excited that we felt we could fly to Vancouver without getting on an airplane. The book has written accounts and the most treasured photos. Sometimes it has little mementos. When I write I don't censor and I don't worry about style. I just want to get it down.

I'm sure a lot of the stuff will not interest whoever is going to read it, because you can't share all your interests with another person. I'm sure the kids will skip a lot of stuff. But they'll likely be interested to know our thoughts and feelings, and of course they'll be interested to see the chronicle of their own lives as seen through their grandparents. That's one of the most important aspects. I feel we're sort of the keepers of those times. We all forget our childhood. We aren't aware of the joy that we bring to our elders. We can't appreciate it until we ourselves are adults. But once one is an adult, one does begin to appreciate the beauty of childhood, the freshness and sweetness that children bring into our lives, their joy and enthusiasm which is quite special because it's so focused. It's not complicated with other knowledge. They can keep their eye on what really counts, and what's important, and teach us those lessons.

Barbara's scrapbooks include records of trips, family occasions, significant events that involve friends, and whatever is especially meaningful to her. Although she was inspired to keep the book for her grandchildren, it is clear that she is making the scrapbooks for herself as well. I asked her what she feels when she looks back over her books.

It does whatever any journal will do, to help you look at things in a different way. Retrospect is often a good teacher, as Dante tells us, and Proust and others. You do learn when you look back.

As her eldest grandchild, as soon as I was old enough to pay attention to any of this, she set to work to make sure I shared the value of family history with her.

—P. E.

COMPILING RECORDS OF
CHILDREN'S LIVES

I met many women who put scrapbooks together for their children only after the children had grown up. While their children were small and life a bit hectic, there was barely time to throw things into a file or a box. Later, they could be sorted out at leisure and put into scrapbooks. These books are wonderful gifts for children as they leave home or start their own family.

But there are some people who are motivated and organized enough to make books for their children as they are growing up. Judi Porter is one of those people. An experience she had when she was fifteen years old made her decide that when she got married and had children, she would keep scrapbooks for them.

> I remember going to my girlfriend's house, and she pulled out this scrapbook that her mother had kept for her, and it was wonderful. And I looked at it, and it showed what she looked like at every age, what she wanted to be when she grew up, and I thought, Wow! It's not fair! Why don't I have something like this? And I thought, When I grow up, I'm going to do that for my children.

Judi tried keeping the baby books that have spaces for first words, first playmates and so on, but found them too limiting. So she started using large hardcover expandable scrapbooks for her children, now aged nine and twelve. She keeps things over the course of a year, and at the end of the year she puts them together in the book. She sorts and edits as she goes along, so as not to have an impossible pile to organize. What sorts of things does she keep?

> Oh, ribbons from sports days, because our family is quite athletic, swimming badges, ski progress records, team pictures from the sports they do, piano certificates, the pictures of their class and their individual portraits each year, gymnastics certificates, a play they went to, report cards, tickets from major trips like the time we went to Disneyland—just whatever they did that year that they have a memento for goes into the scrapbook.

I want my kids to say "my mom kept the things I wanted."

—J. P.

There are so many things you think you will never forget, but someone asks you about it and you realize that you do forget. I know it takes time, but you just make the time to do it because it is a priority.

Quite another type of scrapbook was maintained by Elizabeth Campbell as her now-adult children were growing up. She compiled scrapbooks for each of her three children of the things that she felt were especially meaningful to them individually. For instance, in her son's construction paper scrapbook are pictures of seals and rabbits which he loved, theater programs from children's plays he attended, a newspaper article about the raccoons that were discovered just up the street from their house, a carefully printed letter from a friend thanking him for a special birthday present, a wrapper from a favorite candy, wildlife stamps, Boy Scout brochures and badges, pressed flowers he grew in the garden, ticket stubs from a hockey game, and more pictures of animals and birds.

When Matthew, now married, looked through his scrapbooks for the first time in many years, he was extremely moved by the tangible reminders of his childhood and the memories of the things that were dear to him.

Sandra Moe's son was recently married, and it has spurred her to think about how to pass on the photos and memorabilia of his life to him in scrapbook form. Her son was born in Mexico, and she is no longer married to his father, but she has mementos of that time that are important for him to have.

> I was trying to get some order in my things, and there were some letters from my first mother-in-law. She's dead now, and these letters were written in Spanish, which my son does not read. But I'd like him to know a little about how much she cared for him. There are mentions of him in her letters.
>
> I've always thought it was important for children to know as much as possible about their heritage. Maybe there's some unpleasantness, but it's important to know they were loved.

Sandra has made albums for her son with pictures from his first two years, but she is also making a scrapbook which will include a fam-

As the kids get older, it's easier to be more objective about what you really want to keep. When they first come home with something they've just glued, how can you throw it in the garbage?

—R. D.

ily tree and letters as well as mementos and photographs of his ancestors.

Many people who make scrapbooks for their kids start them with pictures of ancestors, and the genealogical data that the child needs to locate himself within the family. It's a good idea to make color photocopies of precious photographs and valuable documents. This permits you to make several copies for young people in the next generation, and to ensure that the originals are safeguarded. Valuable documents should be treated with particular care, and photocopied rather than pasted in books. Consult page 18 for more information on archival materials and preservation, and the Bibliography for references to further reading.

Legacy scrapbooks, whether personal history books, books made specifically for and about children, or books of family chronicles that you will read about in the next chapter, are made with an eye to the future, in the knowledge that several generations will value them in the years to come. It is up to you to choose a format that suits your taste and budget, and to make your own decisions as to what to include. No matter how you choose to make it look, whether formal or informal, highly decorated or more simple, if the book is put together with love and care, you can be very sure that it will be treasured many years from now.

THE PRINCIPLES OF
ATTRACTIVE PAGE DESIGN

Anyone can design an attractive scrapbook page. Even if you think you have little or no artistic talent, by keeping a few basic principles in mind you can create a beautiful page using the same techniques that graphic artists use all the time.

Think about what you want on your page. Is your layout going to include photographs and text only? Will it include cutout images, stencils, and drawings? Each of these elements can work together well if you think about how they fit together on a page. Keep it simple and remember that even famous designers work with a few standard devices and design solutions to make visually satisfying layouts. Keep in mind also that part of the charm of the scrapbook is the personal quality. The care and love that go into creating your pages are a big part of what makes scrapbooks special. It doesn't have to be perfect. In fact, a well laid out page with a few "quirks" such as imperfect handwriting, odd little sketches, and borders that aren't ruler straight just make them more interesting.

DIVIDING THE PAGE

One very basic principle of both design and photography is the idea of balance. An asymmetrical or informal balance is usually more interesting to look at than a formal or symmetrical balance. When dividing your page keep in mind something called the "rule of thirds." This is a principle taught to all graphic design and photography students, and it is based on the theory that the eye naturally gravitates to a point about two-thirds up a page. By dividing your page horizontally or vertically into thirds it is easier to achieve asymmetrical balance.

When dividing a scrapbook page think about where the photos and text will go after you have drawn in your divisions. How much "white space," or space without any words or images on it, does the page need? Remember that you can use circles and curves as well as squares and rectangles to divide a page. Don't limit yourself. Pencil

in your lines and see how it looks. You can always erase the lines and start again.

Once you have divided your page you can decide if you want to add color or paint to accentuate the division, or simply use words and images to follow the division. You can paste sheets of colored paper onto the page or paint with watercolors (if your paper is suitable) and then add your photos, memorabilia, and words. Remember that when in doubt it is best to go with simplicity. What image or images do you want the viewer to focus on? Too much clutter can be more distracting than charming, so start with fairly basic layouts. Once you feel confident designing a page, start to play with the rules and bend them to pleasing effect.

BORDERS

One way to give a page a cohesive look is to include borders. Borders pull a page or a two-page spread together and give it a unified look, even before you add images or text. Your borders can be as complex or as simple as you like. Stamps, stickers, stencils, writing, drawn-in lines, cut out patterns, and pieces of paper can all be effective borders.

Finally, when you are designing a scrapbook page, have fun. Try different layouts and different combinations of materials before you stick them on the page. Pressed flowers, wine labels, ticket stubs, coasters, menus, programs, and photographs can all work together on a well laid out page to create interest and activity. Think about what is important on a page, about the story you are trying to tell, and let your imagination go to work to create a one-of-a-kind layout.

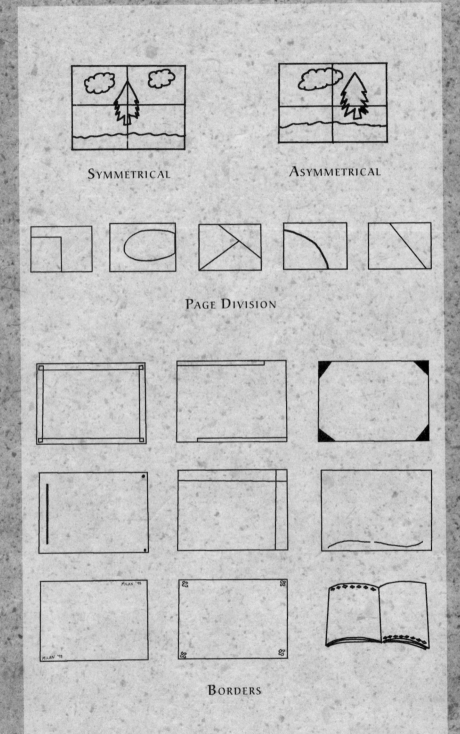

SYMMETRICAL ASYMMETRICAL

PAGE DIVISION

BORDERS

Family Chronicle Scrapbooks

Scrapbooks made for future generations can be personal histories or scrapbooks of our children's interests and accomplishments. But they can also be family chronicles in a wider sense. As well as being an individual, each of us is a member of a family, with ancestors and perhaps descendants. The fabric of our family, however we define it, is part of our identity and is unlike any other in the world. The characters in our family, our patterns of immigration, experiences, values, and stories are always within us. We are who we are partly because of our family history.

For many people, discovering and preserving family history is a fascinating exploration of the past. Genealogy is one part of that history. Searching for the records that reveal names of people for the family tree going back many generations as well as data about their lives can become an all-consuming passion. But the stories and anecdotes about the people on our family tree are equally important, making them come alive in our minds as real people. Scrapbooks are a marvelous way of compiling both the documents and the stories of family members, past and present.

Someone in the family
has to be the keeper
of the records and
I guess I'm it.

—R. D.

WHAT CAN GO INTO A
FAMILY CHRONICLE SCRAPBOOK?

You might be lucky enough to have the documents of past genera-
tions: birth, death, and marriage certificates, letters and diaries, as
well as passports, and school and college diplomas. You might want
to include a family tree or a genogram, a map of where the family
lived and how it dispersed, favorite family recipes, and favorite fam-
ily sayings. Above all, you will probably want to recount stories
about the people in your family, or ask others to contribute stories to
your scrapbook.

Even though my own grandparents fled Europe before World
War II, they managed to take with them many precious family doc-
uments. So in my aunt's basement there is a treasury of boxes of
photos in envelopes, photos in frames, photos in albums. There are
letters written by my grandfather to his parents when he was a child,
and a lifelong correspondence ending in my grandfather's letters to
his grandchildren. There are postcards written by my grandmother
as a young woman sitting in a Viennese cafe to her brother who was
in World War I, and from a later period, neatly bundled letters writ-
ten to her by her adult children. There are historic documents, cer-
tificates, newspaper clippings, and articles and sketches written by
family members. The task of assembling all this could seem daunt-
ing, but a scrapbook can be an ideal way to organize the material.

The first issue to decide is what organizing principle you want to
use. Do you want to assemble the material chronologically, or do
you prefer to take a biographical approach?

DOCUMENTING ONE PERIOD IN TIME:
"IN BONNIE'S SUITCASE"

Maetel Grant has just finished the first of several scrapbooks that
she intends to make about her family's history. She chose to isolate
a ten-year period, from 1936–46, and to weave together the stories
she knows with documents she has discovered. I asked her how the
project started:

My mother died of Alzheimer's when I was forty-five and she was seventy. I remember going back to New Zealand and being with her in her house for about three weeks. She would spend most of her day with this suitcase in front of her, and it was full of papers and photos and bits and pieces. And she spent all day just playing with these things. Sometimes she would talk about them and she was in a world completely of her own. And the last memory I have of her is sitting in her living room with this suitcase in front of her, just poring over these documents. She spent her last three years in a home for Alzheimer's patients, and my brothers just packed her home up and shut the suitcase and kept it. When I returned to visit family in New Zealand some time after her death, I brought the suitcase back here with me.

It was several years before Maetel Grant opened the suitcase. By that time, her children were grown, and she felt the need to find her own roots and to learn her own family story. She traveled to Ireland, to the land her ancestors had been on, and experienced a profound sense of place and connection. A scrapbook was still the last thing on her mind.

My son just got married, and I'm trying to put together a genealogical scrapbook for him.

—S. M.

I wasn't particularly interested in the genealogy, but really interested in the family stories that surrounded the Cambie family. And I went to talk to these old historians, and old people who knew of the family and knew of the castle, and knew how the land had come into the family from Cromwell. To sit and talk to them was amazing because although there are no Cambies there, there's so much folklore that people know. And the other staggering part for me was that the driveway down to the house was about a mile, and it was lined with copper beech trees, old, old copper beech trees you couldn't get your arms around. And it resonated for me because my favorite tree from the time I was old enough to say the word "tree" has been a copper beech tree, and everywhere I've gone in my life, whenever I've had a house, I've planted a copper beech tree.

When she returned from her trip, with a new sense of family history, Maetel finally opened her mother's suitcase. She found her grandparents' diaries, and letters her father wrote her mother dur-

ing World War II. And she decided to make a scrapbook of her family chronicles for the ten-year period from 1936–46, using the material she found in the suitcase as well as whatever she was able to find to supplement it. She managed to weave together the various elements into a portrait of those years in the life of her extended family.

Her grandmother's diaries, which appear in their entirety in the scrapbook, were a very important source of information and insight for Maetel.

> In 1936 my father is first mentioned in my grandmother's diaries. Over the three years from 1936 to 1939 my dad was a very frequent visitor. He built the hen house, he built the pig house, he cleaned the garage, he cut the grass, he cut the hedge, he dug the potatoes, he painted the bath, wallpapered the walls. He was a very busy person. I know all that from the diaries. The diaries are amazing, what she did in a day, who came, who visited. They don't have much feeling, they are mostly recording.

One of the insights she gained from reading the diaries carefully for use in the scrapbook was that there were characteristics that she and her grandmother shared.

> There were funny little things, like I've always had a thing about doing the laundry. I mean, I love to do laundry. And my grandmother loved it too; she talks about doing laundry a lot. And then Allan has always talked about when I get really busy he just stands against the wall, because I'm like a dervish. I go through the house with such intensity and energy that he just doesn't know what to do. My grandmother talked about having "the busies," and how she'd paint the ceiling and dig the garden and do this and that in a day. And when I read this to Allan, he said, "Some things are just inbred. That's what you have, 'the busies.'" And at another point, she talks about having "the bakes." I'm like that too. Every once in a while I'll just bake and bake, and he said, "My god, there you are again."

In addition to diary excerpts, Maetel included in the scrapbook a selection of the letters exchanged by her parents which gave her precious insight into their lives.

For me at fifty-four, when I look at my life and my connection to my mom and dad, I always thought I was the spirit of my mother. And when I read the love letters my dad wrote to my mother, about his hopes and dreams, for his life and the life of the children, and what he valued and what were the most important things to him, I realize that it is something I could have and would have written exactly, verbatim. And that was very encouraging for me because my dad died in 1982, and because I lived in Canada and he lived in New Zealand we hadn't had a lot of connection in the latter years. When I read the letters, there were times when the tears would just be rolling down my face because of the very real outspoken love my dad had for my mom.

As well as the letters, diaries, and a selection of photographs were documents such as her parents' wedding invitation and certificate, death certificates, newspaper clippings of her mother's twenty-first birthday party, and other documents. Eventually, Maetel produced a beautiful book in which she let her own voice be heard in the text, and for which she chose the paper, cover, and binding carefully to reflect the fine quality that she wanted. The title of the book is "In Bonnie's Suitcase," because that's where the story was found.

Clearly, for Maetel, the process of assembling the documents, understanding the lives of her parents and grandparents, and telling the stories was of very great significance to her. I asked what it meant to her to have made this scrapbook.

> I think there's such a treasure there, and the incredible sense of continuity of family. It's fabulous to know that you're so much a part of a history of caring, that it's all been done before, and you get over things and carry on, and life evolves and families evolve, and there are going to be births and deaths and marriages and hard times but they're all there. They're all in the family story.

My oldest daughter found an old album that showed me with a former boyfriend, and she was astounded. "You had a boyfriend?" So then you have to tell the whole story, about how that was before you met Daddy. They love to hear all that kind of stuff. Our parents didn't have any evidence of a past life.

—C. D.

A BIOGRAPHICAL APPROACH

The chronological approach is one way to organize a family chronicle scrapbook. Adam Waldie chose to organize his documents, pic-

tures, and stories by dedicating a few pages to each person. At the top of the introductory page is the person's name, dates, photo, and brief genealogical data such as marriages and burial place. That information is followed by Adam's recollections and stories. For example, about his Uncle Jack, Adam wrote:

> In many ways, Jack was the most colorful of the Waldie family. At the age of twenty-one, with his fourteen-year-old brother Andrew, he availed himself of a Salvation Army resettlement scheme whereby the Army would advance the fares of unemployed young people from the U.K. out to the "colonies." The agreement was they would repay the Sally Ann when they could.

And the account continues, with anecdotes mixed with biographical data and photocopies of the valuable old documents, with a description of Uncle Jack's death. Adam Waldie told me that he had tried many times to write a family history but was never satisfied. The scrapbook format gave him the freedom to use photos and documents that a purely written account did not allow.

FAMILY HISTORIANS, FAMILY DETECTIVES

In every family, someone has to be the family historian. Joan Fisher is that person in her family. She is assembling family chronicle scrapbooks in three-ring binders, and using plastic archival quality sleeves to hold the precious documents. She uses a family tree for reference and has tried to divide the documents according to the people concerned. She is going through the pedigree chart with her mother, asking her about everyone, and writing stories to be inserted with the documents. Her background as a social worker makes her curious about how people become who they are, and she looks to family stories for answers. Like Maetel, she is interested in what made her ancestors the people they became.

> There's a story my father told me about when he was little. He and his baby half brother were visiting an old bachelor neighbor's house, and a

The books I'm making are mainly for my kids. It's rewarding for me, but I see how much it means to them.

—C. D.

huge cat was on the mantel shelf while my dad was sitting in a rocking chair. My father told me that the cat jumped onto his baby brother and tried to kill him. The bachelor yanked up the cat in one hand and his rifle in the other hand, went out the door, flung the cat up in the air, and shot it. My father told me that story more than once. And he would never have a cat in the house after that. So somebody has to keep that story.

Joan Fisher has assembled a vast array of photos, census records, copies of wills, death certificates, letters, eulogies, memorial cards, and obituaries, newspaper articles about relatives, the hockey cards of a cousin in the NHL, her father's final pay stub from the company where he worked for thirty-five years, and poems written for special family occasions. She says:

> I had a friend who had breast cancer; that's when I started wanting to write everything down about the family. If I were to die today, my son would have a sense of where he comes from. In some way I'm doing this to explain something so other people won't have to figure it out as much as I did.

Because I don't have children, my contribution to the family is to keep the photo albums, take pictures of the kids. My family calls me the family archivist!

—D. E.

INTERVIEWING RELATIVES TO
DISCOVER FAMILY STORIES

Many of the stories that are part of the family history and lore are not found in written documents at all, but lie in the hearts and minds of family members, particularly the older generations. In these days of busy and mobile families, children often grow up without learning those important stories that used to be told around the dinner table. Maetel Grant wrote some of those stories in her family chronicle scrapbook. But she also suggested to her younger relatives in the scrapbook itself that they discover other stories and find their own connections with people in their family by sitting down and talking with their family elders. I have written about this at length in a previous book, *Keeping Family Stories Alive* (Hartley & Marks, 1990, 1997).

As I get older, I need to spend more time organizing the stuff I've saved. Frankly I'd rather do that than go shopping.

—S. M.

TOPICS FOR DISCUSSION

One approach to the taped session is a life story interview that covers the teller's life and recollections from the beginning. You might start by asking what that person knows about the history of the family, her recollections of her parents and grandparents, and move chronologically through her life. Sections of the interview could be used at various points in your scrapbook, to highlight turning points or significant events in the family's history.

If your scrapbook is about a specific time, you may want to ask questions about that particular period in the family life. You may decide to ask questions about everybody's childhood or teen years. Or it is possible that your questions will be focused on a category such as holidays, family traditions, occupations, hobbies, or relationships.

Another approach is to go through photo albums, asking the teller for memories and reactions to photos. If you are using copies of any of the photos in the scrapbook, the stories will make a natural commentary.

If you have the scrapbook in mind when you conduct the interview, you might frame some questions specifically around memorabilia that you wish to include. For example, if you have a marriage certificate, be sure to ask the teller for memories of the wedding. If there is a college graduation diploma, you might ask for stories from college years. If there is a newspaper clipping about a drama performance that your teller was involved in, her memories will give life and color to the formality of newspaper writing.

Whatever your focus for the interview, here are a few guidelines:

Before the interview

- I strongly recommend recording the interview using audio- or videotape, since the voice of the teller is as unique and precious as the stories he or she will recount. For the best recording, an external microphone (a clip-on works well) is far preferable to depending on a built-in microphone.
- Practice using the equipment so you are thoroughly familiar with it.

- Prepare for the interview by talking to other family members, thinking about what you want to find out, and writing an outline of questions.

On the day of the interview

- Set up the recorder in a quiet location where you and the teller will be comfortable.
- Start the tape rolling and introduce yourself and the teller. Use earphones to monitor recording.
- Ask open rather than closed questions (e.g., ones that begin: "Tell me about . . ." "Describe . . ." "How did you feel about . . ." "Why . . .").
- Use memory jogs such as photos, diaries, heirlooms, collections, cookbooks, awards, maps, or anything that will evoke stories.
- Don't be afraid to ask for more details of emotions, sensory memories, impressions that will make the stories more vivid.
- Listen with your heart as well as your ears and intellect. Try to be very present, non-judgmental, and accepting of what the teller says.
- Remember that an interview is a collaboration between teller and interviewer. The better the rapport between you, the better the interview will be.

After the interview

- Punch out the tabs on the cassettes, label them carefully, make copies, and keep the original in a safe place.

from a scrapbook:
To know how sweet
your home may be,
Just go away but keep
the key.

—ANON

TREASURING THE AUDIO- OR VIDEOTAPE

Although you may have started an interview with an elder with a view to collecting stories for your scrapbook, you will soon discover that the tape itself is precious. A person's voice is as unique as a fingerprint; it is a reflection of the person's background, personality, sense of humor. Listening to the voice of a loved one with its inflections, lilt, distinctive phrases, pauses, and chuckle will bring the person back to mind with a rush years after the interview is com-

pleted. You may want to make a special box for the audio- or video-tape that matches the paper in the scrapbook. Instructions for a videotape cover are found on page 123.

A FINAL WORD ABOUT
STORIES IN SCRAPBOOKS

Stories put flesh on the skeleton of the family tree. Stories can show us the core values and principles that guided the lives of our ancestors and help us see where our own values coincide or diverge. Since stories are always filtered through the heart and mind of the teller they cannot be an absolute truth, but are the emotional truth as seen from the perspective of the individual. No matter whether the stories are sweeping sagas of immigration and change, or tiny fragments of descriptive narrative, family stories are perhaps our most valuable possessions.

Recording them on tape, and transcribing the significant sections into a scrapbook, is a way of preserving them for generations to come. The stories can be used to explain objects and photographs, or simply written by hand or on a computer and included in the scrapbook. They will certainly bring to life the objects, photos, maps, and documents in your family chronicle scrapbook.

RESTORING OLD
SCRAPBOOKS

Old scrapbooks are often among people's most valued possessions. They may contain a lifetime of important family memorabilia and frequently, original documents of historical value to an individual or family. So how can you rescue an aged scrapbook that is beginning to fall apart? You have a couple of options for saving objects that are permanently glued to a page. The first and simplest is to use a color photocopier and copy the item onto acid-free buffered paper. The original may not survive, but at least you will have a very realistic copy. This method also preserves the aged, worn look which often gives a sense of history and meaning to a document. If you want to try and preserve the original you can cut the item out of the page or leave it on the page and spray the whole thing, front and back, with a deacidification spray (available from museum and library supply catalogues). The spray won't reverse damage but will prevent any further deterioration.

Once you have rescued an old page or document you will want to store it safely. You can encapsulate original documents in Mylar or in archival quality boxes. If you want to put valuable documents rescued from an old scrapbook into a new scrapbook, make sure to use the most durable kind and keep the pages in non-offgassing plastic sleeves or acid-free envelopes. Do not bend or fold old documents or re-glue them. Attach them using photo edges or archival tape.

Often the scrapbook itself, rather than the pages inside, is coming apart. If this is the case, you can transfer the pages into plastic sleeves, and place them in a binder or other book after you have carefully cut the pages out and treated them with deacidifying spray.

RUBBINGS IN THE SCRAPBOOK

Rubbings are a wonderful accent in the scrapbook. You can take your pages and do rubbings right onto them or cut out the rubbing and glue it to the scrapbook page. Some people like to do rubbings

of old gravestones (many years ago this was a very popular pastime among family historians), and these rubbings can be a fascinating addition to a family history scrapbook. Also, rubbings of any textured, engraved, or embossed surface fit well on a scrapbook page. If your rubbing is too big for your scrapbook page consider folding it up and only gluing part to the page. To take rubbings use a cake of wax or pastels (available at art supply stores), lay your paper on the object, and rub it to transfer the impression onto the paper.

Making a
Papier-Mâché
Video Cover

M ost family memorabilia collections now include at least one
videotape. Videotapes may not fit into scrapbooks but you can
create wonderful video cases that either complement or mimic your
scrapbooks. You can make a video cover to match any scrapbook,
and then keep your books and videos together in an attractive multi-
media library.

To make a papier mâché videotape cover you will need:
A plain videotape cover
Two pieces of medium- to heavyweight cover board 4 1/2" x 8"

Wallpaper paste
White glue (PVA)
Several sheets of newspaper
White latex paint
Six small cardboard circles (approximately the same size as the head of
 a post)
Gouache or acrylic paint in the desired colors
Polyurethane varnish
Paintbrush
Craft knife
Ruler
Scissors

Figure 4-1

METHOD

1. Cut your pieces of cover board to create a ³/₄" hinge (Figure 4-1).

2. Glue the cover boards to the videotape cover using white glue, leaving a ¹/₄" space between the larger and the smaller piece. The ³/₄" hinge section should overhang the back of the video case by about ¹/₄" and the larger section should extend over the front of the cover by at least ¹/₄" (Figure 4-2).

3. Place a medium-sized book or other weight over the video case and let the "covers" dry.

4. Glue the six small circles where the posts would go on a book (Figure 4-3).

5. Mix up the wallpaper paste in a large bowl. Dilute the paste with a few tablespoons of water. Tear the newspaper into thin strips running along the grain of the paper.

6. Working on top of newspaper or plastic bags to protect your workspace, cover the "book" with three layers of newspaper strips. Work carefully to cover the "posts." Remember that the

Figure 4-2

Figure 4-3

video will need to fit inside the case, so don't extend the strips into the actual video case. Run the paper strips in opposite directions so you can see what you have covered (Figure 4-4).

7. Allow the cover to dry for three days.

8. Paint the entire cover in at least two coats of white emulsion paint. Allow to dry thoroughly between coats.

9. Paint the cover leaving the middle white to represent pages in a book. You may want to use a contrasting color for the posts. Allow to dry.

10. Varnish the entire outside of the scrapbook video cover.

Figure 4-4

Figure 4-5

Chapter Seven

Trip Scrapbooks

Vacations and travel take us away from our everyday lives and lead us to new landscapes and different activities. Whether we are traveling solo, with a partner, or in a group, venturing thirty miles or three thousand miles, travel gives us a different perspective on the world and on ourselves.

Every destination has its own special sights, sounds, smells, tastes, and ambience. Many times we travel to places whose history, society, and culture are very different from our own. Scrapbooks are a way of documenting a trip and of preserving mementos that bring the entire experience back to memory many years later. Putting a scrapbook together gives us the opportunity to reflect on the important aspects of our trip, and on the meaning that it has for us.

Whether you choose to tell the story by means of photos, journal entries, sketches, a selection of memorabilia, a video camera, or some combination of all these elements is up to you.

YOUTHFUL TRAVELS

If you are lucky enough to have done some traveling as a young person, it is possible that you kept a scrapbook. Several of the people I

talked with said that a trip to Europe as a child or teenager was their first foray into scrapbooking, because there was so much that was new and different, and they didn't want to forget anything.

Erin Wild kept a scrapbook of the year her family spent in Australia when she was twelve. The middle of three daughters, she is the one who saved memorabilia such as photos, notes from the many friends she made, brochures of places they visited, ribbons she won in athletic competitions, a newspaper clipping with her picture in it. When she returned to Australia last year at age twenty for another visit, she kept another scrapbook. This one was slightly different.

From a trip scrapbook: Peas, peas, peas. Always with our meals in England. Even with eggs and chips, which are fries.

> It was when I started traveling by myself that I really picked it up and wrote in it. That might be also because I got really lonely at times. I'd write a lot, especially when I got to a new place and didn't know anyone. I'd kind of go into this hidden-away mode, where I'd hide for a few hours or a day and write in the book. So this one doesn't have many photographs; it's mostly a journal. It's got quite a bit of poetry in it, and there's little stubs of tickets from places I went to. And I'd ask people I met to write or draw in it, and write their addresses. They'd write funny things of what we did together. I've got maps, and recipes people gave me, and a certificate from when I went bungee jumping.

One story of a Europe scrapbook comes from Cassandra Smythe, who went on a school tour to Italy about twenty years ago. She says candidly, "I thought it would help me get a good mark if I did a really good job." For Cassandra, a good job meant a very neat and thorough scrapbook which must have included every single bus token, boarding pass, ticket, and a napkin from every trattoria they ate in. Remembering herself as a high school student, she said with a smile, "When you look at other people's books, I could say mine was better than theirs because I had more stuff. It was just more complete. It's almost a compulsion to have everything. It's like being a collector."

Cassandra showed me this marvelous scrapbook:

> It starts with a notice to parents about the proposed trip, promotional brochures, approval from all the teachers and assignments we had to

do because we missed a week of school, extra passport photographs, going-away cards (our family keeps Hallmark in business!), luggage tags, boarding pass, a page of postcards and photos from Rome, a ticket stub from the ride to the top of St. Peter's Dome. And this I just had to save: a few pieces of the truly awful toilet paper they had. And here's a photo of friends in front of a fountain in Barberini Square, a napkin from Trescallini with the notation "I ordered a chocolate gelati tort truffo," bus tickets from Rome in an envelope, pictures of the teacher chaperones. Here are some extra lira, some telephone tokens, the case for my traveler's cheques. Here's one thing I was sorry I couldn't put in a scrapbook: I won a bottle of champagne. But I did save the winning ticket....

Anita Boonstra did a study abroad program in 1975 in England and Holland. It was a program that focused on language, art, culture, and history. Her scrapbook is full of all kinds of interesting memorabilia as well as drawings, etchings, small details of buildings that struck her fancy, and very thoughtful and candid written observations and reflections about what she saw.

On one page where there are pictures of a church, Anita wrote: "One big gripe now about churches which are opened as museum pieces. Really gives me an uncomfortable feeling sometimes. Is it the house of God or a museum? In a small cathedral in Oxford we walked in on a service, and also in Edinburgh. While the tourists were wandering around in the cathedral, the priest stood up on his pulpit for noon prayer and scripture. Just seems to clash a bit." And on another page: "Peas, peas, peas. Always with our meals in England. Even with eggs and chips, which are fries!"

As we looked through the yellowed pages together, Anita remarked: "I'd forgotten this stuff! Just looking through it, the memories come alive! It takes me right back there." The mementos that Anita kept ranged from maps, brochures, and music concert programs to a few photos ("I didn't take a lot of photos because I couldn't afford it"), a rail pass, a map of the London Underground, pressed flowers and leaves, and coins in the foreign currencies carefully taped into the book. Anita emphasized that the scrapbook was

When someone asks me: "Oh, how was the Utah trip?" I don't remember. But then when I look at the scrapbook, I do.

—EVAN, AGE 11

not done to be shown to others. In fact, she said, this was the first time she had ever shown it to anyone else. "It was a way of charting my adventures, putting it all together, a way of remembering."

Sandy Goodall has vivid memories of the beginning of the year she spent in Europe:

> This is an article from the local paper about my trip. In our town, nobody went to Europe, not in those days. When I left town, I took the train to Montreal to get the boat. Half the town came to see me off, because it was such a big event. My father was in a state of shock. He still didn't think I was actually going to leave and go to Europe. He kept saying, "There's an awful lot of nice places to see in this country." But the day came and off I went. And my mother, I'll never forget this, she was running down the platform shouting, "Pin your money inside your dress!"

from a scrapbook:
For my part, I travel not to go anywhere, but to go. I travel for travel's sake. The great affair is to move.

—Robert Louis Stevenson

Every item in Sandy's scrapbook evokes stories and reminiscences. I asked her about a bill from a pension in Majorca. What does that bring back for her? "Oh, everything, everything. That's the first place I ever saw a lemon tree. I grew up a hundred miles from James Bay. I'd never smelled perfume in the air because we didn't have fruit trees in the North. And I couldn't figure out where the smell was coming from. And it was lemon trees. It was an absolutely gorgeous scent."

A telegram pasted in the scrapbook reads, "Send itinerary. All fine. Love, Mother." Sandy says now:

> We had our mail sent to American Express offices. They were the places that had American-style toilets and always had hot water. So we used to go from office to office and wash our clothes in the sinks. Then we'd take them and hang them over a bush at the side of the road while we were hitchhiking. We washed our hair, we washed everything when we got to American Express offices. Then we picked up our mail. Now I think of my mother, and can't believe how worried she must have been! As a mother myself, I understand why she wanted our itinerary, but at the time I remember thinking, "Why does she need to know where I am all the time?"

All the stories of Sandy's "hitchhiking days" are in the scrapbook, brought back to memory by the telegrams, photos, clippings, brochures, and found scraps of memorabilia that crowd the pages.

For all these people, the trips they took as young people were extremely significant events in their lives. The scrapbooks connect them with the young people they once were, exploring the world at a time of life when everything was fresh and exciting and possible.

CONTEMPORARY TRAVELS

I discussed with several people the fact that they traveled before video cameras became common. They all agreed that video recordings cannot replace scrapbooks, because scrapbooks permit a far more personal recording of the events, emotions, and experiences. As Marie van Barneveld said, "With video, people don't record their impressions, what they're thinking and feeling about what they are seeing. They just record what is there."

Maxine Shaw has always kept scrapbooks, so it's natural for her to buy a special book for her mementos when she travels. She documented a trip to the Cook Islands in a small (5" by 9") coiled sketchbook, just the right size for putting in her bag. It is also, not coincidentally, just the right size for grandchildren to handle as they look through it. The scrapbook includes brochures from the art immersion program she was on as well as the lodge where the group stayed, followed by a handwritten list of "What to take with me." Attractively cropped photos of tourists and islanders, endless beaches, and exotic plants, as well as Maxine's attractive sketches, are interspersed with journal entries of her impressions and comments. The scrapbook also contains pressed flowers, business cards, and postcards. Together it makes a book that is evocative for her and fascinating for others.

Maxine's mobility has been greatly reduced in the past few years, and she sees her travel scrapbooks as even more important now that she can't get around as well as she used to. When I asked her what the scrapbooks mean to her, she replied, "These books ring a bell inside me!"

from a scrapbook:
One's mind is like a parachute. If it stays closed you're lost.

—ANON

Going into the castle
and the manor house
where my great grand-
father had been born
and had been raised,
and on the land where
he lived, I can't even
begin to tell you how
powerful that was.

—M. G.

TELLING THE WHOLE STORY

Travel scrapbooks, for the most part, reflect happy memories. But we all know that trips aren't always perfect, and things do go wrong.

If you were to look at Cassandra Smythe's scrapbook entries for the three-day turnaround cruise she made a few years ago, you'd see a going-away card (remember, this is the woman who said her family kept Hallmark in business!), a postcard of the ship, the brochure with information about the ship, official photos and snapshots, a picture of the Captain's Dinner. But the story behind the objects is a little more complex.

> I was so sick. Everyone was sick. The air conditioning blew out as soon as they turned on the engines, and we were all sick. They had to priori-tize people in terms of who got medication. The ship's doctor was too sick to go to the captain's cocktail party. We hit a real bad patch off the Oregon coast. But everyone got a new cruise about ten months later that was just fabulous.

This made me wonder how one would tell the real story of a trip that didn't go exactly as planned. And I had a chance to talk about that with Nancy Pollak, who had just come back from a sea kayaking trip on the West Coast. I asked her how it went.

> Well, first of all we got caught in a storm. The beach we were heading for has long mudflats, and at low tide you can't kayak in, and we had to haul our gear a long way in (and we were carrying a lot of food and too many books). Then my friend got really, really sick and had a fever for two days, and then we got stranded and couldn't get the kayaks off the beach, so we had to be rescued from the beach by the water taxi.

And what were the photos of the trip like? "I think they are of us sit-ting smiling on the beach in front of our tent."

Too often, the real story isn't told by the photos. I asked Nancy what she would keep if she were making a scrapbook that evoked the trip as it really was. "I'd keep the receipt from the kayak rental place, the folded tide tables that are brittle from being soaked with rain, wrappers from the tinned sardines we ate, shells and feathers

we collected on the beach, the crumpled soggy business card of the water taxi driver, the receipt from the motel where we stayed when we finally got to town, and maybe a coaster from the pub from that evening when we talked about our trip. I'd call it 'Our less than sweet experiences on Savary Island'!"

A trip is merely a sequence of events until it is shaped into a story by the traveler. Trips are particularly suitable subjects for scrapbooks because, like most good stories, they have a beginning, a middle, and an end. When you make a trip scrapbook, you, the storyteller, put your own spin on the events; you select details and highlights that are unique to your vacation. You can emphasize aspects that are positive or negative, funny or challenging. Your trip won't be the one seen in travel brochures, nor the one you read about in other people's travel writings. Your experience of Paris as a twenty-year-old is very different from your experience of Paris as a fifty-year-old. A cruise to Alaska taken by a couple for their twenty-fifth anniversary will be very different from that of a recently widowed woman, because of the experiences and emotions the travelers bring to the trip. The scrapbook is a way of telling the story of your unique voyage.

Making an Accordion-Style Scrapbook

This book makes an innovative small scrapbook. This project can lie flat or be left open to show what is inside. Accordion scrapbooks are particularly suitable to display favorite photographs of a trip, or perhaps for recording memories of a party or a special occasion. This version of the accordion scrapbook features a two-tone cover technique, but you can simplify the cover by using only one piece of cover paper or cloth.

To make an accordion scrapbook you will need:
Inside paper

You will need a piece of paper at least 30" long. The paper should be at least six times longer than it is wide.

Cover boards

Cut two cover boards ¹/₄" longer and wider than the pages of your scrapbook.

Cover paper

To make the two-toned scrapbook cover, choose two pieces of cloth 1 ¹/₂" longer and wider than the pages of the book. Then cut one piece of complementary or contrasting cover paper 1 ¹/₂" longer and wider than the cover boards.

Cardboard

A piece of cardboard 1" wide and the same height as your pages to make a jig.

Paste or glue

Bone folder

Awl

Pencil

Ruler

Utility knife

Scissors

Book press or heavy weight large enough to press your covers as they dry

FIGURE 5-1

METHOD

1. Measure out the length of your pages and mark the spot with a small hole using your awl (Figure 5-1).

2. Using the holes as your guide, fold your pages with the bone folder, making sure the top and bottom are aligned (Figure 5-2).

FIGURE 5-2

3. Cut two pieces of cover cloth 1 ¹/₂" longer and wider than the cover boards.

4. Cut one piece of cover paper 1 ¹/₂" longer and wider than the cover boards.

5. Fold and glue the fabric onto the cover boards using the universal corner (page 34). Smooth the fabric to make sure it covers the boards and there are no air bubbles or threads between the fabric and the board.

6. Folding the single piece of paper on a diagonal, run your bone folder over it several times, turning it inside and out (Figure 5-3). Rip the cover paper carefully along the creased line.

7. Glue one half of the torn cover paper onto each of the cloth-covered cover boards (Figure 5-4).

9. Wrap the cover boards in waxed paper and let them dry under a heavy weight.

10. When the boards are dry, glue the first page of your folded scrapbook pages to the front cover board. Glue the last page to the back cover board. Press open the covers of the book, and separate them so the moisture from the glue doesn't warp the accordion pages (Figure 5-5).

FIGURE 5-3

FIGURE 5-4

HINTS AND TIPS

You can paint, draw, and write on your accordion scrapbook as well as use it to display photographs. If you want to write and draw extensively on the pages, it is simplest to do it after the pages are folded, but before they are attached to the cover boards.

FIGURE 5-5

Special Interest Scrapbooks

For many scrapbookers, there is pleasure in keeping not only personal mementos, but also ones that pertain to areas of special interest. There can be great satisfaction in gathering material relating to world events or hobbies, and having a scrapbook filled with these things to keep them in one place. Scrapbooks may also contain collections of everything from matchbooks or wine labels to pressed leaves or pieces of fabric.

When I asked people why they kept scrapbooks, a number of people mentioned their love of collecting things. In my correspondence with ninety-one-year-old Evelyn Horton, she has talked about her collections of miniature bottles, old pens, pencil sharpeners and buttons. At various times, she has also mentioned scrapbooks of cartoons, stickers and stamps from envelopes, children's stories clipped from magazines which she used as bedtime reading for her own children, pictures of animals, pictures of birds, samples of unusual wrapping paper, craft ideas. Before going on to write about the collections kept by her son, she commented: "I think there must be a collecting gene that runs in some members of a family!" And these scrapbooks were in addition to the more personal ones she has kept about the events of her life from the 1920s to the present!

Doing the scrapbook
about Kennedy took
me out of the reality
out of my daily world.

—R. W.

SCRAPBOOK OF CURRENT EVENTS

World War II, the coronation of Queen Elizabeth, and the assassination of John F. Kennedy are a few of the subjects of scrapbooks I was shown. Done by people at different stages of life, in different countries, at different times, all are still treasured today by the people who created them.

Bob McDiarmid was a boy of twelve when he started his scrapbook just before World War II began. He remembered seeing a book with pictures of World War I and it made him realize that this was another important moment in history. So, with an uncannily mature sense that he had the opportunity to record history as it was being made, he decided to keep a scrapbook with pictures and articles. "I had some kind of sense that I was going to show somebody some day, if not only myself, that these were real pictures and that this really happened. It wasn't just a story. I suppose I knew that one day I'd be looking at it as the past."

Each page is laid out with care, and it is not hard to imagine twelve-year-old Bob intently combing newspapers and magazines for articles, pictures, and political cartoons. The fact that his older brother was in the air force was perhaps what drew Bob to focus on cutting out and drawing pictures of aircraft. The captions on the photos reflect the emotionally turbulent times: "The agony of France's collapse." "Four of the sixty wounded men aboard the battleship *Admiral Graf Spee* are shown lying on cots while comrades attend them." The scrapbook contains instructions for using gas masks, an article about the shooting down of the Red Baron, a picture of a four-wheeled vehicle propelled by pedal power with the caption: "Gas shortage brings out the family bike." While the printed book from World War I made the war seem remote and unreal, the scrapbook of World War II was more immediate. "I wanted to be sure that these pictures were true, that they were real pictures."

I asked Bob what he thought about when he looked at the scrapbook now. "It makes me realize that I was smarter than I thought I was; that I had a sense of history. It also makes me aware of how I felt when I was fourteen or fifteen; just like when you hear jitterbug

music, you remember how you felt dancing to the nickelodeon, those great feelings you had when you were younger. With this I remember the sense of solidarity. That's what wartime does to you. People think like one person. There was no animosity or road rage or anything. It was all a spirit of 'when this war is over.'"

Lynn Smith remembers the coronation scrapbook she kept as a child.

I was in first grade in 1952, the year of the coronation of Queen Elizabeth II, and kept a coronation scrapbook. It's a tattered mess now, but it was one of those special books with a photo of her on the cover. I remember I wrote, "Inside this book is a photographic record of the Coronation of Her Majesty Queen Elizabeth II" on construction paper cut into a neat square and pasted onto the front cover, being careful not to cover up anything important. I started it about a year before the coronation, cutting out photos from newspapers and magazines. I was reading quite early, so cut out some long articles too. There was so much leading up to the coronation, and I got so into the preparation that the scrapbook was almost full before the actual event. It taught me a good deal about forward planning. Anyhow, I had to start a second book.

My favorite photos were ones of the queen as a child. There's a lovely one of her in a bonnet looking solemn and beautiful as she does now. There were photos of the queen's marriage to Prince Philip, and ones of her and her sister, Princess Margaret. And there were some supposedly candid shots of Prince Charles at four or five climbing out of a window, and his little sister, Anne.

This was my favorite activity when I came home from school. I'd kneel down on the living room floor with the magazines all around and LePage's glue for sticking in the pictures. One of the things I remember is that I really wanted it to be complete. By that I mean I didn't want to miss anything good. What was important was all the pictures of the regalia, and all the articles about clothing, what she was wearing, how heavy the crown was, that kind of thing. Of course this led to the problem I already mentioned of crowding at the end.

It's an outlet for me. The only way I can describe it is that I've always kept scrapbooks and always known family members who do too. I know I always will.

—S. J.

On November 22, 1963, Richard Wilcox was a young Englishman of twenty-one. He remembers the shock of coming out of a London movie house into a crowd of people shouting and screaming that President Kennedy had been assassinated. Although he wasn't a particularly political person, the assassination affected him deeply. He began buying three or four newspapers a day and cutting out articles to make a scrapbook. What was it about John F. Kennedy that affected him so deeply?

> When you're a young man, you want someone to look up to. "The new frontier," a new way of life, the youngest president. It was like hope to a new generation. He was for the people, a real democrat. He represented idealism.

In the end, Richard made five enormous scrapbooks containing only articles, pictures, and information pertaining to Kennedy's life and death. The headlines, now over thirty years old, still have the power to move and shock: "Kennedy Assassinated," "Children and Jackie kneel at the coffin," "Did Oswald kill the president?" "On the verge of greatness," "United in sorrow," "The shot that shook the world." Richard's interest led him to read at least twenty-five books about the Warren Commission, and in his apartment are displayed several framed photographs of the Kennedy brothers. This has clearly remained a lifelong interest.

Although Richard Wilcox now lives on the west coast of North America, the scrapbooks came with him from England. Like Bob McDiarmid, Richard has a sense of history: "Perhaps I like to keep this somewhere so people can look back and see who Kennedy was. I don't know exactly why I did it, but it was important to me to make these books." And also like Bob, he feels that "you can study history by reading from books but a scrapbook is more personal."

from a scrapbook:
Never in the field of human conflict was so much owed by so many to so few.

—WINSTON CHURCHILL

HOBBY SCRAPBOOKS

Scrapbooks provide a method for keeping ideas and information on a particular subject in an organized way. From the child who makes a book about different breeds of dogs, to the adult gardener who col-

lects articles and pictures about horticulture, people who have special interests find scrapbooks both useful and enjoyable. They are fun to make, and serve as handy reference books as well.

Sandy Goodall is one of the most prolific scrapbookers of my acquaintance. As well as the ongoing chronicles of her life and travels, and a marvelous book for her grandson, she has made many special interest scrapbooks. She made scrapbooks of animals and animal stories for her piano students to read as they were waiting for their lessons. She enjoys reading small local newspapers when she travels, so has a special book for the mastheads of those newspapers to remember them by. She has a scrapbook for gardening, another for birdwatching, and yet another for astronomy which shows all the constellations that she can identify, as well as new sightings and new discoveries. She makes recipe books for her children to preserve the favorite family recipes. And it gives her great satisfaction to make all these books.

> When you meet a person and find out what kind of books they read, you get an insight into what sort of person they are. And scrapbooks do the same thing. They tell an awful lot about you, because they show what you think was worth saving, what meant something to you, which is really what you're all about. And if you throw everything away, that tells something about you too!

For just one more example of a special interest scrapbook, I asked Betty Dwyer about her book of family recipes. Her best-loved recipes are written on computer, cut to a 4" x 6" template, and put in plastic sleeves in a small ring binder. The book is easily duplicated for other family members. Of course, recipes are very evocative of family stories.

> My favorite recipes are in this book. A lot of my grandmother's recipes are here. This is a marmalade recipe from my father's sister—it's a good one. But this is my grandmother's recipe for marmalade—that's the best one. Subtle. Wonderful marmalade! And cheap—it makes gallons. And here's a rhubarb marmalade. That's the one my mother used to make. It was delicious. And here's a great recipe for hot pear chutney

Glen was very active in sports, and his family kept all the newspaper clippings and that stuff. That gave me an idea of where our kids get their interest in sports. History does repeat itself, there's no question.

—C. D.

and spiced dill carrots. That's quite good. And this is an old family recipe for mincemeat. It starts out with one and one-half pounds of suet, three pounds of raisins, five pounds of currants. You have to mix it by hand because the darn thing is so heavy. That tradition is that everybody has to put their hands into this, you see. You have to scrunch it up with your hands. My son-in-law was absolutely horrified. But he did it anyhow.

We are all fascinated, moved, and absorbed by different things in life, and these interests are reflected in the scrapbooks we keep. While it is certain that many people worldwide have Princess Diana scrapbooks, it is just as certain that others weren't motivated to keep any of the thousands of pictures and articles about her published during her life and after her death. One ten-year-old girl might spend hours doing scrapbook pages about the Spice Girls, while another is fascinated by horses. What draws us to our own particular area of interest is always a bit of a mystery. But making a scrapbook is a way to document and expand our interests, loves. and even our obsessions in a creative way.

Making a Découpage and Raffia Scrapbox

The beauty of the découpage scrapbox is that you can make a box that will perfectly complement your scrapbook. If the cover paper of your book contains pressed flowers, think about making a box using flowers you have pressed and dried yourself. You can also adapt the découpage technique to the cover of your scrapbook if you have used heavy-duty plain paper that will stand up to varnishing.

To make a découpage scrapbox you will need:
Cardboard box

A cardboard box large enough to hold the memorabilia that won't fit in your scrapbook. (Shoe boxes work well.)

Paint

High-gloss paint in any color (you can also use satin or matte paint, depending on the finish you want).

Découpage materials

Cutout images from wrapping paper or magazines or very flat pressed flowers.

Raffia

A length of raffia that looks attractive with the découpage images and box.

Lining

A length of fabric or tissue paper big enough to line the inside of the box.

Embroidery needle

Your needle should have a large enough eye to thread the raffia through.

Paintbrush

White glue

Scissors

Awl

Matte varnish

FIGURE 2-4

METHOD

1. Paint the outside of the box with at least two coats of the high-gloss paint, allowing it to dry between coats.

2. Cut out the images you want to glue to the box, or pick and dry the flowers you want. (See page 95 for more details on drying flowers.)

3. Arrange the cutouts or flowers on your box. Glue the back of each piece and press them into place, making sure they are flat. (Rubbing the paper cutouts softly with your fingers will help to eliminate any air pockets.)

4. Once the glue has dried, cover the entire box with a layer of varnish. Let it dry and then add another coat. Keep coating the box with varnish until the entire surface is smooth and the cutouts or flowers no longer raise the surface of the box.

5. Punch holes approximately 1" apart around the top of the lid with an awl. Thread the raffia through the needle and, beginning at the corner of the box, sew around the lip of the lid. Tie off the raffia once you reach the corner, leaving a length sticking out to act as a handle or tying the end piece into a bow for an accent (Figure 6-1).

Making a
Secret Scrapbox

This classic scrapbook box is the stuff of high intrigue for children and those who love a surprise. It is made by hollowing out an old hardcover book to make a space for any small objects that won't fit comfortably in your scrapbook. Consider using it to store audio- and videotapes as well. This is not a project for old beloved books! Use old hardcovers that you are certain you don't need. Old encyclopedias or old textbooks make good choices. Hunt around at secondhand bookstores and garage sales to find old books, making sure they are thick enough and big enough to make a good box.

To make a secret scrapbox you will need:

Book

An old hardcover book large and thick enough to make a box when hollowed out.

Glue

A large UHU glue stick.

Lining paper

A piece of 11" x 17" construction paper, or heavy decorative paper such as a marbled paper .

Board

A piece of hardboard such as masonite to make a cutting template.

Utility knife

Ruler

A thin flexible cutting board

Scissors

Book press or heavy weight large enough to press your book as it dries

Figure 7-1

METHOD

1. Decide how big you want the hole (box) in your book to be. Cut a piece of hardboard to that size to use for a cutting template.

2. Open the book to the back page and, leaving several of the last pages free, begin gluing the pages to one another by applying glue to the flat page and very carefully folding back the next page over it so that they sit smoothly and evenly together. Make sure the pages sit flat on one another, as an accumulation of wrinkles will ruin the effect of the secret compartment. Glue together about 1/2" width of paper, one page at a time (Figure 7-1).

Figure 7-2

3. Once you have a section of pages glued together, place a thin flexible cutting mat between the glued pages and the rest of the pages and back cover. Place the cutting template where you want the compartment and with the utility knife, cut around the

template until you have cut out the shape of the compartment (Figure 7-2).

4. Glue together another ¹/₂" of pages and cut out the hole until you have only ten or so pages left at the front of the book.

5. Glue each of the ¹/₂" sections to one another and press the whole book with a heavy weight for a day or two.

6. Measure out the interior dimensions of the box and form the decorative paper into a lining (Figure 7-3). Glue the lining into the book.

7. Let the whole thing dry for a couple of days before putting treasures into it. Make sure to file it discreetly in the library where it will blend in with its neighbors (Figure 7-4).

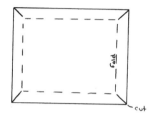

FIGURE 7-3

FIGURE 7-4

Children's Scrapbooks

Many of the people whose scrapbooks are described in the preceding chapters kept scrapbooks as children. Barbara Cook fondly remembers her primary school scrapbook, made out of bread wrappers. Violet Burgess kept scrapbooks with pretty pictures that gave her pleasure to look at. Kerry Howard started scrapbooking with pictures of dogs and horses cut out of magazines when she was eleven or twelve.

Maxine Shaw still has the scrapbook she made as an eleven-year-old. An artist from a very young age, her early scrapbook contains drawings: a self-portrait, sketches, even drawings of her wardrobe a few years later. Although her parents separated when she was twelve, her scrapbook record of traveling with her parents to the Chicago World's Fair, then by train to New York, New Orleans, west to Los Angeles, and up the coast brings back memories of the years when her parents were happy and times were fun.

These women, all in their sixties and seventies now, were young at a time before television, when children had to create their own entertainment. Making scrapbooks was one way of keeping busy, of making something personal and artistic, of keeping a collection of

things of interest. Paper, scissors, glue, pictures, and kids have long been a natural combination.

Children's scrapbooks have often been about heros and hero-ines. Cassandra Smythe remembers a scrapbook she made about Karen Magnussen, a Canadian figure skater who lived in the same city as she did.

> It was a really big thing. There was something in the paper every day about her, and I was just fascinated with figure skating and always hoped to be a figure skater. You could dream when you were nine. I kept every single newspaper article, the pictures of the homecoming parade, the magazine covers, the drug mart flyers where she was ad-vertising stuff, and I had a huge book. Who knows why I was so fasci-nated? When I was fourteen or fifteen, and finally cleaning out the bedroom because my parents were nagging me about cleaning up, the whole thing went in the garbage. Now I'm really sorry I threw it out.

That's a fairly common story; the scrapbooks that young people put together tend to be made with less permanent materials, and get tossed out as people grow up and leave home. That may seem like a good idea at the time, but is sometimes later a cause of regret. Reesa Devlin recalls the scrapbook she made as a teenager.

> I kept ticket stubs from all the movies and plays I went to and other things like napkins from special events. I remember dried corsages and pictures from parties. If a date took you to a restaurant you'd take home a stir stick and a coaster and glue them into the scrapbook with a scribbled notation of the name and date and the year, and if I happened to have a picture, I'd put that in. And years later when I went through my non-collecting stage, I threw all of it away.

How does Reesa feel about not having that scrapbook?

> I feel as though I've lost a part of my history, because now my children are at that age, and I want to show them things. So I'm sorry I threw them out not because they were wonderful heirlooms, but just for the kids to see the kinds of things we did as kids. Unless you see it, you can't really understand it.

The stories can of course still be told, but the memorabilia contained in classic scrapbooks adds a great deal to those stories.

CONTEMPORARY CHILDREN'S SCRAPBOOKS

What kind of scrapbooks do children of today keep? If one reads the current magazines devoted to creative photo albums, it would seem that children, like many parents, are mostly fascinated by the decorative products of the hobby industry. But there are still some kids who do classic scrapbooking. They use "found" objects and drawings of their experiences rather than just use photos in enhanced albums.

Elyse and Evan Henderson are nine and eleven respectively. They have been encouraged to keep journals and scrapbooks from a very early age by their mother, Melanie. When I went to their house to look at their scrapbooks, Elyse showed me her first one, done on a trip to Mexico when she was only three. There were stick drawings with captions such as this one: "This is the acrobat I saw on the boat, and this is me." And there were airline tickets, ice cream bar wrappers, and stickers.

I asked Melanie what role she played in the scrapbooks:

> We'd sit down each night and I'd say, "OK, what did you want to record about today, what was important about today?" She'd tell me and I'd write it down. Or she would just draw a picture about the day and I would write what she told me. I encouraged both kids to record something every day. It didn't actually end up being every day, and sometimes it was more than encouragement, but they've learned over the years that it's worth doing because we enjoy going back over the books when they are done.

At five years old, Evan made a slightly more sophisticated scrapbook in Mexico than his sister's. His airplane tickets are glued in without such reckless abandon, much of the printing was done by him rather than his mom, and he included some made-up stories. He was also a little more adventurous with the things he chose to paste in the book: the sticker from a sandpail he bought, a bread wrapper

from a scrapbook:
Dachsunds are ideal dogs for small children, as they are already stretched and pulled to such a length that the child cannot do much harm one way or another.

—ROBERT BENCHLEY

from the first white bread he had ever eaten, and lots of drawings of Mexican taxis, delivery bicycles, and police vehicles. One of the most interesting pages contains a drawing of a tree with a bright orange flower, and glued beside it a dried pressed brown flower that used to be orange. Beside it was printed: "This flower I found on the ground. It's a pretty color, dark orange."

Last spring the family went on a trip to China, and the kids had to decide how they wanted to document it. Although Melanie kept a combined journal and scrapbook, the children decided to keep separate journals and scrapbooks. Not surprisingly, they have both become committed journal writers, but evidently part of the fun for them was collecting the visual stuff that was so very different from the things one would find at home. The pages are filled with maps, colorful tickets to the Palace Museum, the Forbidden City, the Temple of Heaven, the Great Mosque, the Great Wall, the Terra Cotta Warriors, tickets for trips they did by plane, by boat, by train, labels from soup packages, fruit-flavored milk, Chinese ginger ale, wrappers from ice cream treats, and an empty package of spice-covered watermelon seeds which still carried an exotic smell. There were also placemats from McDonald's, Pizza Hut, and other fast food outlets!

The children were pretty clear about why they kept the scrapbooks. Elyse said, "It's fun collecting stuff, and it's sort of a neat way to remember stuff when you get older." And when I asked Evan what it would be like if he went on a trip and didn't collect things to put in a scrapbook, he said, "I'd be sorry. I'd want to go back and get it. It would be kind of hard to remember things if you didn't have the scrapbook."

And Melanie, listening in the background, said with a laugh, "Good, I've got you guys addicted!"

From a child's scapbook:
All events are preordained and unalterable. Whatever will be will be. That way if anything bad happens, it's not my fault. It's fate.

—CALVIN & HOBBES
CARTOON

A PARENT'S ROLE IN A
CHILD'S SCRAPBOOK

It seems to me that the greatest trick in helping your kids keep scrapbooks is to encourage without taking over the project. What

children think is important to keep may not be what a parent thinks should be kept. Melanie Henderson is very aware of this.

> It requires a lot of encouragement to make sure all the materials are in place for them to do the books. And then because you put so much energy into it, it's really easy to want to take over and say, "This is how you're going to do it." But I have to back off. I really do believe that as long as I set the scene so they are able to do it, then it's up to them how they want to do it. It's their life, it's their remembrance of the experience, and I shouldn't put my cookie cutter on top of that. So I hold off saying, "No more junk food placemats; it makes me look bad. No more candy wrappers; it looks like all I did was feed you candy!" These scrapbooks are about what was important to them when they did the trip, not what was important to their mother. It was hard for me, but I backed off.

Debbie Clelland started making books with her four-year-old son Duncan about a year ago. In her case, it's a matter of literally making the books, not just finding things to put in them! Duncan participates in creating each book from start to finish. They've made books about Christmas, about a trip to Hawaii, and the one I looked at which was the story of a weekend spent with Duncan's grandparents. The cover is just cardboard, covered with construction paper that Duncan chose and cut out himself. The story is told with words, drawings, photos, and because part of the story was about the time they spent at the beach, some shells and rocks glued into the book, and a sand dollar in a plastic bag that can be taken out and examined.

Debbie told me, "I thought it was a neat way to do something that was a little more interactive than just looking at pictures. The book is a storybook, and we spend a lot of time reading."

One of the important aspects of the process for Debbie was that it sensitized her to Duncan's point of view, made her really listen to her son, and engage him in conversation to see what he thought was important, or he liked. So for example, on one page the story reads: "We went shopping and I got a bouncy ball," indicating clearly which part of the shopping trip interested him. She knew which were his favorite shells and rocks because he wouldn't let go of them. When I suggested they would have to be small shells to fit in

Scrapbooks provide a memory about who you were, how great you were, how funny you were, how eccentric you were, how artistic you were, how interested in so many things you were, how engaged you were in your life.
—M.R.W.

a small book (it measures about 4" x 6"), Debbie said sensibly, "Well, small boys tend to keep small things in their pockets."

Making books is clearly going to be part of the activities that Duncan and his two-year-old brother, Logan, continue to do in the future. Asked what the value of making the book was, Debbie replied,

> It challenges me to be creative and to think like a three-year-old, which I like to be able to do. And it's an opportunity to remember the things that we've done, that were special to us. It gives us a chance to keep the treasures we've found in a special place so they don't get lost, and in a way that we'll be able to look at time and again. And it's a way for us to interact on a different level than we would otherwise, to sit down and say we're actually going to make a book today. Sometimes it takes several days. You have to pick whatever the best time of day is, usually not after lunch, because the boys can be rather hyper then. It's a way for them to be able to participate in creating this memory of things and places and people, and it's a way for us as parents to be able to talk about the important issues that we're involved with, like making sure we don't kill the little animals inside the shells, or we don't pick all the flowers because the next people want to see them. So it's a gentle lesson in ecology. I think of it as trying to teach them respect for all the beings and things that are growing and living in the world. So it's another way to incorporate that in a gentle format that isn't just me nagging.

Putting together a book like this has value that goes far beyond the fun of making it. It honors Duncan as well as his grandparents by having a book all about them. It preserves his treasures and will create memories in the future. And it might become an early reader for him in a year or so. Judging by the proprietary way Duncan showed me the book, I'd say he is very pleased with it, and so he should be.

CHILDREN'S SCRAPBOOKS
AND SELF-ESTEEM

It was obvious to me, when the children showed me their scrapbooks, that they were very proud of their creations. A deeper under-

There's just so much stuff the kids bring home. How to edit is key.

—C.D.

standing of the importance of scrapbooking for children came from Mimi Rondenet-White, a clinical psychologist who works with children and adolescents.

> Self-expression, especially in childhood, is essential in order to develop a sense of your authentic self, or to know who you are, as differentiated from your brothers and sisters and parents. A scrapbook provides the authenticity of your uniqueness. It's more like an art form than a document. So who am I and what interests me, what hurts me, what concerns me, what do I think is beautiful, who do I admire, who are my heroes, where are the places I've been that are really important to me— those are the threads that weave together to create the fabric of who you are as an individual.

There are many ways of expressing oneself—in writing, in art, and in music—but scrapbooking provides something unique.

> Scrapbooks are important in that they're two-dimensional and three-dimensional. They're not just writing and collage or photographs, but they have objects in them: shells and feathers and flowers from a friend's garden, or the puppy's tooth that fell out when it got its adult teeth, or the dog's license tag from when the dog died. It's icons of important events that you can look at and touch and feel. It's not just inscriptions or representations, it's actual objects. Objects are really important to children. All their little treasures and what they represent to them — to be able to see those things and have them saved in a way that represents their importance is really powerful.
>
> Let's say your grandma gives you some funky little ring she found at a garage sale. And after a while you're not wearing it anymore because it turns your fingers green, and maybe it wasn't really good metal so it cracked. So you tape it into your scrapbook, and you write: "Grandma gave this to me. She told me that I'm special when she gave this ring to me." And then when you're thirty, you can look at that and say, "Gosh, I did have someone who knew I was special in the family."
>
> My daughter Sky is twenty-five and still loves her scrapbooks. At one point, when she was maybe ten or twelve, she wanted a safe for Christmas. And I said, "Why a safe?" And she said, "So I can put my

Even now in schools teachers are encouraging children to write journals and biographies , and those are treasures you keep forever. Maybe that's the way we'll tell our stories. Everything's so technologically driven, it's nice we retain some things that are photographs and stories and not just plug in the video machine.

—D.E.

scrapbooks where nobody looks at them, especially you!" That's how important they were. They can't be contaminated by adults looking at them, and analyzing them, or commenting on them.

And Mimi believes that years later, they provide a valuable memory for people of what they were like when they were young.

> I think it provides a memory about who you were, how great you were, how funny you were, how artistic you were, how interested in so many things you were, how engaged you were in your life. So memory is really good for people to have about what their process has been in becoming an adult.
>
> Children are much deeper than we think they are. They're much more insightful and articulate. And because they live in the world of adults, they censor so much of those sorts of expressions. But in a scrapbook, they don't have to, and they can use it for themselves, or share it with other people if they want to. But it can be very private and unique and validating and interesting, and I think it's an important way that a child can talk about who they are and what they're going through, what they've been through, what's important to them, and what their values are.

Children are naturally drawn to the making of scrapbooks; they can draw, write stories, decorate with stickers, keep treasures like shells and feathers and tickets and brochures. What they put into a scrapbook is limited only by their own imagination. They can be public or private, personal or impersonal. Parents can help facilitate the process by making the supplies available, and getting involved if that's appropriate for the age of the child. Years later, if the scrapbooks survive, they are a valuable and poignant reminder of the stories, feelings, and events of childhood.

We got a car in 1950 and my father took us all to visit relative that we'd never seen and then we went to Ottawa. And I was so taken with it. I had a little camera, and when I got home I made a scrapbook of the trip and wrote down all my impressions. I was 13 or 14.

—S.G.

Kids' Scrapbooks

Kids love making books and a scrapbook made from scratch is even more special than a purchased one. When kids get a bit older their books can become more complex, but in the meantime even the youngest scrapbooker should be able to make this simple project.

To make a kids' scrapbook you will need:

Cover boards

Two 8 ¹/₂" x 11" pieces of heavy cardboard or posterboard (Kids' books undergo a lot of wear and tear so they may not last, even if they are made with archival quality paper and materials).

Paper

Several sheets of cardboard or cardstock.

Binding
> A piece of yarn or string.

Decorations
> Offer the kids a collection of old newspapers and magazines and crayons and felts to decorate the cover and the pages (optional).

A hole punch or awl (if the kids are very young an adult should use the awl and punch the holes)

White glue

Scissors

METHOD

1. Help or supervise as the kids punch holes the same distance apart in the front and back covers and in the pages. There should be at least three sets of holes in the book (Figure 8-1).

2. Tie the covers to the pages using thread or string (Figure 8-2).

3. Decorate the cover (and pages) with drawings, writing, and cutouts!

Figure 8-1

Figure 8-2

HAND- AND FOOTPRINTS

One particularly fun activity for a kids' scrapbook is to make a hand- or footprint in the book or right on the cover. Use watercolor paint or gouache, mixed with some water in a bowl or a plate, and press a hand or foot in the paint. Press the wet hand or foot onto a page or cover, leaving a very original stamp. This technique is also great for parents who want a poignant record of how much their kids are growing. Take a baby foot- or handprint and put it in the scrapbook you plan to give your child at graduation.

Making a Reversible Sewn Scrapbook

S imple but very lovely, the sewn scrapbook is perfect for saving keepsakes from special events.

To make a reversible sewn scrapbook you will need:

Paper

Use ten sheets of cotton rag paper that, when folded, form the page size desired.

Binding

You will need a sewing machine and thread to complement or contrast the paper.

Fastenings

Some type of fastener such as a fancy hairclip or even a diaper pin.

Paintbrush

METHOD

1. Tear the paper to form rough edges (see page 67 for making rough edges).

2. Fold each of the sheets in half and, gathering them together, sew them down the middle with a straight stitch of average length (Figure 9-1).

3. Fasten with a pin or a clip.

FIGURE 9-1

Chapter Ten

Memorial Scrapbooks

When someone dies, through all the grief and sense of loss the stories remain. In the days immediately following the death of a loved one, it is natural to want to be with others who knew and loved that person, to share memories and experiences. This sharing is an important part of the grieving process, and one that finds expression at funerals and memorial services. On those occasions, it is not uncommon to find oneself smiling through tears while listening to the eulogies and testimonials that focus on the life of the person who died, rather than their death.

When the sharp edges of grief are softened by the passage of time, it is possible to think about creating some kind of memorial that captures the essence of the person you have lost. Making a memorial scrapbook is a cathartic process that will result in a treasured document that honors the memory of the deceased.

ELI'S BOOK

My grandfather was always very interested in personal histories, just as I am, and believed it is important for people to know the stories of their elders. When he wrote an autobiography and self-pub-

lished it for the benefit of his family and friends, he prefaced it with a quotation from the Psalms: "That which we have learned from our parents, we shall not withhold from our children."

And when his eldest son, Eli, died suddenly at the age of twenty-four, a year after getting married and with a pregnant wife, my grandfather dealt with his grief by producing a scrapbook of his son's life. In this scrapbook he included stories and poems that Eli wrote as a child, drawings that he did throughout his life, photos of the teenaged Eli's magnificent sculptures of horses, letters, excerpts from a diary Eli kept, and a selection of photos that showed the young man from childhood to young adulthood. Grandfather also included reminiscences by friends and family members who were close to Eli.

I can only imagine that the process of putting the book together was a healing one for my grandfather, a way of dealing with the overwhelming grief that he must have felt. For my cousin who never knew his father, the book provides precious insight into the person from whom he inherited his considerable creative talents. For other family members who have seen the scrapbook, the volume brings many different aspects of Eli's personality into focus, making him a real person to those who didn't know him, and ensuring that he will not be forgotten. Without the scrapbook, I think he would be just a name on the family tree.

From a scrapbook:
He has not lived in vain who leaves to his friends a legacy of sweet and cherished memories.

CHOOSING A FORMAT

If you are making a memorial scrapbook, the way it looks will be very important. If the book is to honor the memory of someone special, it will likely be more than a newsprint scrapbook. That doesn't mean that you have to spend a fortune on an album, but it does probably mean that you will want to use archival materials and put it together with some care and attention to the appearance.

Patricia Evans had a manuscript of her grandmother's life story, which her grandmother wrote in the form of a letter to Patricia.

In the late 1970s, my grandparents were in their nineties and my grandfather was dying, and my grandmother had a lot of time on her

hands. And it occurred to me that although she had told me a lot about certain things, there were gaps. I guess I knew the idea of asking her to remember would appeal to her. Because of my grandfather dying, I was also very conscious of losing the memories and I wanted to give her something positive to focus on. So I wrote to her and said, I've only really known you since you were about sixty, and obviously a lot of interesting things happened before that, and I only know a little bit of it. I'd really like it if you would write down some of these things.

She ended up writing ten thousand words. She was such an achiever, she didn't do anything by halves. It's incredible in its clarity and coherence. It was all handwritten; she just bought pads of writing paper, and sat down and wrote. It must have taken her hours. But it feels like she really enjoyed it; the tone of it is quite lively.

I think she went back to the times when she'd been very happy. It turned out she'd had an amazing life, far more so than I was aware of. So I decided to transcribe all this. The rest of the family was vaguely aware that it existed.

She died in 1987, and about three years ago I decided it was time I did something with her book. Then I started to think about the pictures, because she'd been careful to give me her pictures before she died. She believed that when her parents died, her brothers had burned most of their parents' memorabilia because they didn't think it was worth anything, and she was very angry about that and wanted to be sure that that didn't happen to her precious things. So that's what I have—everything from her marriage license to her nursing school graduation certificate, to my grandfather's demobilization papers from the war, to pictures that soldiers drew of her when they were in hospital and she was nursing. I also have her pin that she got at graduation, my grandfather's cap badge from his uniform, her mother's button hook for her boots, and her father's corkscrew, but I keep those in a box.

Patricia decided to make her grandmother's life story into eight books for herself and close family members. Each book had a slightly different handmade cloth-bound cover.

I wanted it to be beautiful, so that it would be a keepsake that people would be proud to have and accessible in their home, not put away

From a scrapbook:
Sunset and evening star,
And one clear call for me,
And may there be no
moaning of the bar,
When I put out to sea.
—ALFRED TENNYSON

somewhere. What I wanted to do was have something that reflected my love for my grandmother and would have an heirloom quality about it. And I've been very gratified with the response, which would have made her very happy, that her story didn't languish somewhere.

Along with the text, which Patricia herself designed and typeset, were beautiful photographs affixed to the pages with black photo corners, just as in old-fashioned albums. Each of the books is truly a work of art, and the presentation of her grandmother's story certainly reflects Patricia's love for her. (For more information about making multiple copies of a scrapbook see page 175.)

I absolutely see the scrapbook as part of the healing process for Sam, and for him to remember his grandfather.

—D.M.J.

A LIFETIME OF SCRAPBOOKING

When Evelyn Horton was twenty-nine, in 1936, her parents died within a few months of each other. Evelyn had grown up with scrapbooks ("I thought everyone kept them!" she said) and so it was clear to her what should be done with the box of memorabilia that they left.

I made a large scrapbook from all the clippings, pictures, and certificates. I wanted to preserve their memory and preserve anything they may have treasured.

A few years later when I got married, the next book had, on the first page, sketches of our hobbies, then one of building our first home, places we visited, etc. When my husband died, after thirty-eight years of marriage, aged eighty-five, I carried on with our book. I thought about making six copies of the scrapbooks for his family members who didn't have much about him. He had a box of items—his discharge papers from the army from World War I, a certificate for his invention of the sawdust burner for kitchen stoves, and so on. I had copies made of each. I put the original in the one for myself, now my son's.

As I finished each book for my husband I put it aside until I had finished all of them, then mailed them the same day. The replies I received were all very appreciative, and they were pleased and surprised

that I would take all that "trouble." To me it was a pleasure to live over again the many pleasant memories of our lives together.

WHAT SHOULD BE IN
THE SCRAPBOOK?

Just as each person's life is unique, each memorial scrapbook is unique as well. It can be built around writings left by the person, as in Patricia's case, or alternatively, you as the creator of the book might write a biographical sketch and add photos, mementos, newspaper clippings, or whatever is appropriate.

You might choose to solicit contributions from other people. The person who died may have been your wife, but she was probably also a mother, daughter, aunt, friend, employer or employee, colleague, teacher, or neighbor. Everyone will have a slightly different perspective on why she was important to them, and different stories to tell. No one person can have a complete understanding of all the various aspects of another person, but a scrapbook made with the contributions of many gives a more complete and rounded view of a life. People who coordinate such scrapbooks often say that they learned a great deal about their loved one through all the stories that emerged.

The collection of mementos you add will evoke the personality, interests, and accomplishments of the subject of the scrapbook. Pressed dried flowers from her garden, a picture of her bowling trophy, a few favorite recipes, a thank-you card sent to her for some act of kindness, a sample of her embroidery work, some reminder of her professional life, together will help paint a portrait of the person you want to remember. Sometimes it is the everyday details that create stories that people will remember in the future. The fact that she loved a certain kind of bread, or that she enjoyed playing checkers with her grandson, or that her living room smelled of orange blossoms can be reflected or written about in the scrapbook. In other words, the scrapbook doesn't have to be a grand and adulatory biography; it will keep the memory of the person alive if it encompasses

That was the most wonderful thing for me, to hear people talking about my Dad in ways I'd never suspected. So just getting to know my parents as people was really good!

—L.L.

stories and recollections of his or her human qualities and the particular impact that he or she had on others.

HONORING A PARENT

It is not surprising that scrapbooks have become a medium by which information about past generations of a family can be compiled and preserved. Reesa Devlin's mother passed away fairly recently, and Reesa has decided to compile a scrapbook incorporating stories she knows. "Someone in the family has to be the keeper of the records, and I guess I'm it," she told me. "I think with the older generations dying off and lifestyles changing, there are no storytellers anymore, and the younger generation doesn't remember the stories and all of a sudden your children are growing up with no grandparents who reminisce and tell those wonderful stories."

In part, what Reesa is interested in doing is telling the stories she knows about the objects and mementos that her mother kept. For example, among her mother's effects was a punch bowl. And in her mother's box was a picture from 1929 of the same punch bowl sitting on her parents' buffet.

> Originally I thought it was my mother's punch bowl. But now that I know that it was her mother's, and I have a picture from 1929 that shows it, it's so incredible, it's such a treasure. So I want to preserve the story in the scrapbook, by showing the old black and white picture of my grandparents in their house with the table set and the punch bowl in the background. And I'll tell whatever I remember about it, so when my kids grow up and inherit the punch bowl, it's not just a piece of glass that they think maybe is kind of ugly and perhaps they should sell in a garage sale. All of a sudden it's got meaning, it's got history. It was their mother's and their mother's mother's and their mother's mother's mother's, and there are pictures through the generations of how it was used.

In the scrapbook will also be photos of her mother as a baby, as a schoolgirl, as a young teenager, as a young bride, and as an older

The family history books are in the order of a pedigree chart. I'm going through it with my mom, asking her about everyone and writing stories. Then what I will do is make a narrative that will flow through, to go with the documents.

—J.F.

woman. Her mother did a lot of writing—plays, stories, and poems, and a selection of her writings will go into the scrapbook as well.

Other photographs gave Reesa clues as to the origin of things that her mother kept. When Reesa went through her mother's boxes she found a piece of the bedspread her mother had as a young bride. "I guess over the years as it got worn and washed it got shredded, but she cut a little piece of it to keep."

She is planning to put the picture of her parents' bedroom showing the original bedspread in the scrapbook, together with the piece of fabric. "And those will be my memories, and my children's memories. The problem is, if it is just an old piece of fabric, then what is it? The kids will look at it and throw it out. But if there's a story with it, if there's a scrapbook with the original photograph of it, it becomes a treasure."

Reesa has a very clear idea of what this scrapbook will look like. It will be not merely a means of organizing material, but truly a work of art in itself.

> I see it as a large album. And because my mother loved blue, everything she owned was blue, I would think it would be a blue and white theme. My father was in the printing business, so I love beautiful paper; I probably won't get just conventional paper. I'd have it bound with old-fashioned ribbons. And I've got some beautiful buttons that she saved, and it might be fun to make a collage on the cover using buttons and some of the costume jewelry, the rhinestone jewelry that I remember her wearing. It seems a shame to get rid of it. So the brooch could be the knob on the cover of the book. There are pictures of her wearing that brooch that could go into the scrapbook. I've even thought of her long white gloves almost as a piece of art in the book.

This baby book is proof that he was loved. If I were to die, this would say to him that I wanted him and chose to have him and that he was loved.

—J.F.

MEMORIAL SCRAPBOOKS
FOR CHILDREN

The death of a child has an emotional impact that is often too great to express in words. While we grieve the loss of an older person, we

can often accept death as a natural part of life. However, when a child dies, whether through accident or illness, it seems particularly wrong and unfair. No matter how old the child, there are sure to be memories and memorabilia that can be preserved in a special scrapbook.

Parents and siblings may choose to make a scrapbook together. When seven-year-old Tracy Evans died of leukemia, her parents collected mementos in a box: a selection of Tracy's artwork, school photos, reports from kindergarten and first grade, swimming badges, the mask from a costume that she wore last Hallowe'en, a Mother's Day card that she made and printed herself, and photographs that traced her life. Tracy's nine-year-old sister wrote and illustrated a story about the times they went to their summer cottage together. About four months after her death, her family decided to put the mementos together into a scrapbook. Making the book helped everyone deal with their grief, and gave them a lasting testimonial to a very special little girl. The scrapbook is something concrete and tangible, and serves as a vehicle for sharing memories with other people.

> The last memory I have of my mother is sitting in her living room with this suitcase in front of her, and just poring over these documents.
>
> —M.G.

MEMORIAL SCRAPBOOKS
MADE BY CHILDREN

When Darlene Meyers-Jackson's father-in-law died, she asked her nine-year-old son, Sam, whether he would like to make a scrapbook of his grandfather. She felt that it would help in the process of grieving and saying goodbye for the boy to be involved in a project that made him think about his grandfather and accept his death.

N.J., as Darlene called her father-in-law, had lived in the same city as his son's family. Sam frequently accompanied his father, Nick, to have Sunday lunch with N.J. but the older man was quite deaf and unable to get about very easily, so Sam's relationship with his grandfather was limited. As a result there weren't a lot of mementos like ticket stubs or even photographs to put in a scrapbook. However, there were stories. Darlene told me some of them.

N.J. used to make bread, and every time they went for lunch there was always bread there, and they called it "grandfather bread." We have the handwritten recipe, so that's something we put in the scrapbook. Also, I always took N.J. shopping, and sometimes Sam came with me. Last summer, as a treat, Sam asked me for a Big Bar chocolate bar, which I got him. For the rest of the year, N.J. always bought him the same kind of chocolate bar. So I got a wrapper for the scrapbook.

I was kind of shocked to realize that there weren't any pictures of N.J. from the past three years, although we have some of him with Sam when Sam was a toddler. But when we had a memorial service for N.J., the scrapbook idea was in the back of my mind. So I took a picture of the card Sam made, some flowers he bought with his own money, and a lit candle that we had on the mantel.

Darlene was very conscious of not taking over the project, but letting Sam do it himself, a problem faced by many parents. "It's a fine line. I think one of the main stumbling blocks was how much do I guide and lead and organize and how much do I facilitate his doing it the way a nine-year-old wants to do it."

One of the ways Darlene dealt with this dilemma was to ask her friend Ann Bailey to come to the house, set up a tape recorder, and talk with Sam about his grandfather. She felt that would permit his memories to flow without interference or suggestions from her. Some other stories emerged from that session, memories and perspectives that surprised Darlene with their insight, but which were incorporated into the scrapbook. Sam talked about a building set that he always played with at his grandfather's house, and said, "Grandfather liked building things too." Sam's drawing of his favorite creation appears in the scrapbook.

An important by-product of this process was that Darlene now has an audiotape of her son's voice talking about his grandfather, and she realizes what a treasure the tape itself is and will be in the future. A copy of the tape is attached to the scrapbook, but the original is stored elsewhere for safekeeping.

When Darlene first began the project, she saw it as something that could be done fairly quickly. She soon realized that the process

> All the people are dead, and this is meant to honor and respect their memory, not make light of it, and to share their legacy, the incredible gift that we have.
>
> —M.G.

was valuable in itself, and that it might take longer than the morning she had originally planned. She suggested to Sam that they use a scrapbook format that was flexible, and work on one page at a time rather than trying to fill up a book all at once. It made the process much less daunting and more manageable, both for herself and her son.

It is hard to accept the death of someone we love, whether that person is our child, parent, grandparent, or friend. Grieving is a process that takes time, and in that process it is important to think and talk and tell stories about the person we have lost. Making a scrapbook of the person's life and the impact he or she had on us and the world is a healing and cathartic activity and a way of creating a lasting memorial.

MAKING MULTIPLE COPIES AND USING THE COMPUTER

Scrapbooks don't just have to be one-of-a-kind. They can also be created in limited editions! All you need to make multiple copies of a scrapbook is a bit of forethought, and access to a copy center or computer service bureau.

So why would you want to make multiple copies of a scrapbook? Well, for starters, they make wonderful gifts. Family story or family history scrapbooks for several different branches of your family is a great idea. What about a set of accordion scrapbooks for members of a wedding party? Each of your multiple copies does not have to be an exact match with the others. For instance, they can each have different cover papers and fabrics. The scraps, photos, and text inside them may be specific to the recipient. The small differences will be much appreciated, at the same time as there is a real satisfaction in creating more than one scrapbook and in receiving a limited edition of a very personal gift.

THE JOYS OF THE COLOR COPIER

If you are creating several scrapbooks of a family history, for instance, remember not to include any original documents. Items such as birth or wedding certificates can be color photocopied onto heavy paper to make very convincing duplicates. Today's color photocopies are exact enough to recreate the appearance of age. The same thing is true of photographs. To cut expense, instead of having prints made from your photographs, consider photocopying them and then putting the copies in your scrapbook. Wonderful (and expensive) decorative paper can even be photocopied and used as cover paper. Even children's drawings, or original artwork can be copied and put into the scrapbooks for rich effect.

SCANNING

Another option to get several identical copies of the same document or image is to scan them. Your local computer service bureau will be able to scan almost any image or document and print out copies for you at whatever size you need for your scrapbooks. One important advantage of having your image scanned is that you will be left with both an original and an electronic version of your artifact. The scan itself can be stored on your home computer, a floppy disk, and/or another storage medium such as a ZIP disk. Scans are easy to print out and to alter if you are lucky enough to have a photographic alteration program such as Photoshop at home on your computer.

MATERIALS

If you want to make multiple copies of a scrapbook, remember to calculate how much more paper and other materials you will require. Buy all the papers for each book at the same time so they match or complement one another. Cut all of the boards and endpapers together to ensure uniformity.

WORD PROCESSING

Another great idea for scrapbooking is to type your stories and quotes and other text into a word processing program, lay it out attractively, and print it out on good paper. You can then take your printout, cut the edges or tear them to add interest, and glue them to your scrapbook page. This is an ideal technique because if you make mistakes you can fix them and print out another copy, and because you will be left with a copy of that great story on disk for safekeeping. Handwritten words look lovely, but when you are working with more than just a few sentences, word processors are easier to use because you can change your mind about layout and correct your mistakes with very little effort. Also, if neatness is a concern on your scrapbook page and you want to ensure legibility, and your own handwriting is perhaps a bit erratic, typed words are a great solu-

tion. Fonts are varieties of type, and your computer should offer a choice of different fonts, each of which will give your words and your page a different look, from classic to modern. You can make titles large and bold, and draw in rules to accentuate parts of the text or to set off the headings from the body of the text.

Practice arranging your text on the computer. Look at layouts in magazines and other books to get ideas. Good sources for information and ideas for laying out text on a page are desktop publishing guides and books on typography, such as Robert Bringhurst's *Elements of Typographic Style*. If you want very professional layouts for your scrapbook, you can take your stories to a desktop publishing company and have an experienced typesetter lay out the text. They will be able to offer you more choices of fonts and suggest attractive text design, but this is an expensive option. Remember that half the fun of the scrapbook is the pasted, multi-dimensional quality of the pages, so make sure that you cut out your pieces of text and glue them to your pages, and be sure to use acid-free paper. You can paste your scraps right onto the printed sheet.

Tribute and Gift Scrapbooks

Scrapbooks are not simply a way of recording and remembering our own experiences; they can also be a thoughtful and exciting way to mark a special occasion or to give as a gift. There is no doubt that people appreciate the time, care, and thoughtfulness that a scrapbook represents.

BIRTHDAY AND ANNIVERSARY SCRAPBOOKS

Scrapbooks are wonderful gifts to honor people at significant birthdays or anniversaries. Two of the most stunning scrapbooks I saw were made by Peggy Jessome: one for her mother's eightieth birthday, and the other for her aunt and uncle's sixtieth anniversary.

Peggy sent letters to close family members and friends of her mother's, asking them for memories for her mother's book. She collected the responses and used them to fill a beautiful hand-crafted book. The book is covered in shades of dark green, copper, and brown and filled with heavy watercolor paper. On the right-hand side of each double page spread is each person's story, simply entitled "Donnie's Story" or "Barb's Story" and so on. On the left-

from a scrapbook:
Always do right.
This will gratify
some people and
astonish the rest.

—MARK TWAIN

hand side is a paper collage which Peggy created with the contributor in mind, and onto which she affixed photos. The collages give a wonderful texture and depth to the pages. When I asked her how she decided on each individual collage, Peggy laughed. "I just kind of felt around for each person to figure out what was the right background, what were the right pictures to go with it, so it was kind of fun. For some people, you'll see the shapes are very fluid. But this page, with my aunt's story—she always has her hair beautifully coiffed, and she used to wear hats, so it seemed important that this page be much more formal, much stronger, straighter lines. For each one, I wanted to get the feel of the person."

She added, "It was lovely to do, I must say. The thing that was nice about it was that for me it was a way of honoring my mother and really saying that this was a life that was worth living, and also a way of getting to know her better. I mean, there were stories in there that I didn't know. My sister is eight years older than I am, and our parents divorced when I was about two, so my sister has quite different memories of my mother than I do."

Peggy's sister, Barb, contributed several stories, of which this was one:

> She taught me a lot about determination. I remember I was quite young and we were pretty poor at the time. We had the opportunity to go on holiday up to Emma Lake. Mom's first car was an Austin station wagon, and the roads up to Emma Lake were all unpaved at the time. Well, we got our first flat about one-third of the way up. The spare tire was underneath the floor boards, in the back under all the luggage. So we had to take out all the luggage. The second flat was two-thirds of the way up. I think we even got a third flat in one of the spare tires. Mom took all of this in her stride. Once we got there, the adventure continued. Dave managed to get a huge fish hook deeply embedded in his thumb. Into the car we all went to drive two hours to the nearest hospital to get it removed.

Peggy laughed when she read that. "It seems to me that a lot of the stories about Mom had to do with driving."

How did Peggy choose the colors for the book? "I tried to think of

the textures and colors that are hers. So the dark green feels important, and the roughness of it. It partly reminds me of growing up, when there was a dark green feel to the living room. And for me somehow my mother is kind of coppery brown. So it's warm and earthy."

The scrapbook was a surprise for Peggy's mother, Marg. At her birthday party, everybody told their stories and then the book was presented, with people's signatures at the end of "their" page. How did Marg react?

> My mother is a stoic, so she doesn't show feelings very much. So she said to me, "Must have taken a lot of work, dear." But I think she was really quite pleased with it, because she has a special place for it in her house.

Another indication of how her mother values her book is that when Peggy's aunt and uncle were about to celebrate their golden anniversary, Marg decided that the most special gift she could give them was a scrapbook. She commissioned Peggy to do another one. This one is done with different paper, more blues and golds, and Peggy created handmade envelopes to hold anniversary cards and a photocopy of the original wedding announcement. Peggy clearly loves working with paper:

> It's just sensual. There's the color and the texture. For me, one of the things I like about story is the sense of metaphor, and somehow paper is like metaphor. You think about your paper, and see one that's smooth and elegant and the color is rich, and it just fits the people and the stories. The paper for me adds another layer of meaning.

Both books are tributes to loved elders in a family and create connections among the family members who contributed stories. And for Peggy Jessome, the process of making the books was one that enriched her and gave her the satisfaction of having created something of inestimable artistry and meaning. These scrapbooks will most certainly become treasured family heirlooms.

Scrapbooks are important in that they're two-dimensional and three-dimensional. They're not just writing and collage or photographs, but they have objects like shells, feathers, flowers, the puppy's tooth that fell out, or the dog's license tag. It's icons of important events that you can look at and touch and feel.

—M. R. W.

One wants to keep the
scrapbooks because
they're a reflection on
what's happened.
Scrapboooks aren't just
record, but a reflection.

—B. S.

A SCRAPBOOK FOR
A NEW GRANDCHILD

The birth of a baby is a wonderful opportunity to make a scrapbook. Many people keep photos, or fill-in-the-blank baby books. Sandy Goodall decided to make a book for her grandson Thomas for his first Christmas. The pages are laminated, with punched holes, so that a child can turn the pages easily.

> I just used cardstock, 9 by 12. When you open the book, there's a lovely picture of him in the center and in primary school printing I wrote, "This is me." Then on the next page is our daughter Kate in her garden, and I wrote, "This is my Mummy; she likes to work in the garden." Then I took other photos of her garden and cut them all up in bits and stuck them around. Then on the next page, "This is my Dad; he likes to ride his bike." I had a picture of Brad in his helmet. And it went on, "This is where I was born," with a picture of the hospital, and "This is my house. Can you find my room?" His bedroom window is in the front. And "These are my dogs" and then it says, "Now we're a family." And then it goes on to show his four grandparents at his first party, which we had when he was seven days old. And on the very last page, instead of "The end," I wrote "The beginning."

Sandy is already planning a second book for next Christmas, which will be about Thomas' aunts and uncles. It's a wonderful idea, very easy, and a great gift for the entire family.

A ROMANTIC SCRAPBOOK

Before Sara Jewell and her husband married, they lived in different cities. As a special gift, Sara made a scrapbook for him illustrating all the things she loved about him and providing images of their future life together. It's done entirely with scraps cut out from magazines and newspapers; there are no photos. It is relatively small, with a carefully chosen cover. Sara talks about having "curated" the book, which is full of poems, captions, magazine ads, and pictures. The layout is done very carefully and artistically.

For instance, on one page is a picture of a lovely cabin in the woods, and there are two captions, taken from unrelated ads: "Barefoot morning, sweet dreams and an unread book," and the other, "A comfortable day starts here." Any time the book gets really serious, there's a little cartoon that lightens the mood.

"This was a major project," says Sara. "I worked on it every night for about half an hour and did a couple more pages. When I gave it to him, he just loved it. So while we were in different cities, he could sit and read it and have a connection to me, have the romance of all this stuff I wanted to say, but couldn't because we weren't together. So this was in lieu of going out on dates and walking along the water. You make do with a book. It's my favorite thing I've ever done."

OTHER OCCASIONS
FOR SCRAPBOOKS

Once people get hooked on scrapbooking, they realize that many occasions are appropriate for making a special book. Besides the birthdays and anniversaries mentioned above, here are a few others:

- a bridal shower or wedding
- the birth of a baby
- a young person leaving home for college
- a colleague leaving one job for another
- the retirement of a respected boss
- the completion of a special project with a group of people
- the end of a school year, or a school reunion
- a significant musical or dramatic performance
- a festival or conference

You might feel that it is appropriate to give a completed scrapbook on these occasions. Or, you might decide that a beautiful blank handmade book is exactly the right thing as a gift for a newlywed couple, a new parent, or a child leaving home for university. A third option is to start off the scrapbook with a couple of photos or clippings or ideas to stimulate the imagination and creativity of the recipient and to leave the rest of the book blank. You can always find an assortment of pens, stickers, photo edges, borders, and scissors

In a way we don't leave much behind, so this is perhaps our one way of achieving some sort of immortality. We were here, and this is a record of our passing. And these scrapbooks are so important to me that if the house were to be burning down, I think this would probably be the first thing I would rescue.

—B. T.

to wrap up with the book to provide appropriate accents to the pages.

As gifts, scrapbooks are infinitely versatile, able to be used for almost any occasion. A special book to mark a special time is well worth the effort.

MAKING RECYCLED FLOWER PAPER

A square of handmade flower paper makes a lovely mount for a photograph, or a wonderful accent for a scrapbook page on its own or glued to an envelope. For the very ambitious, you may be able to create your own paper for the cover or endpapers of your book.

To make recycled flower paper you will need:

Paper
 Several sheets of plain paper (even newspaper will work).
Food coloring in desired color
Dried flowers
2 tablespoons of white glue
Approximately 3 cups water
A food processor or blender
A sink or a large tray (with a few inches of water in it)
Nylons
Coat hangers
An electric iron
(Optional: threads, dryer lint, dried leaves)

1. Shape the coat hanger into a square slightly larger than the desired size for your piece of paper.

2. Pull the nylons over the square so they are tight and flat. Make as many of these frames as you need. Tie knots in the nylons to close the square.

3. Tear the paper into small (2") squares and put one cup or so into the blender. Add a few tablespoons of water and turn the blender on high. Add paper and water until you have a large, wet mass of paper. Add as much water as you need to keep the blender moving. Make sure all of the paper has been blended into the mass.

4. Put your glue in the sink water and add the paper pulp from the

blender. Add the flowers and food coloring (if desired) and mix it all around in the water.

5. Slide one of your frames into the bottom of the sink.

6. Very slowly, lift the frame out and let the water drain off. You should be left with a layer of wet fibers on the nylon sheet.

7. Repeat the process until you have filled your frames.

8. Put the frames in a warm, dry place to dry.

9. When the paper is absolutely dry, gently peel it from the frame. With your iron on high, steam it flat. You can do this on a dry dish towel on an ironing board.

HINTS AND TIPS

Handmade recycled paper can contain any number of substances and so cannot be considered archival unless you make it using recycled archival or permanent papers. Handmade paper also lends itself to experimentation. Try adding small squares of magazine with letters printed on them and end up with alphabet paper. Leave your paper white and paint it once it has dried. The options are endless, so let your imagination be your guide.

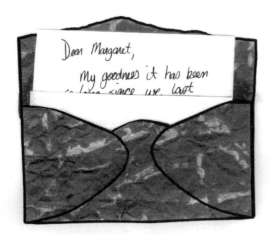

Making Envelopes

If you want to keep original documents in your scrapbook but don't want to glue them in, consider storing them in handmade envelopes. It can be difficult to find archival quality envelopes, and if you are storing original documents it is essential they be stored in acid-free paper. Using your own acid-free paper you can create envelopes that accent or complement your scrapbook design.

To make an envelope you will need:

Paper

A sheet of $8^1/_2$" x 11" paper for regular sized envelopes ($3^5/_8$" x $6^1/_2$") or a sheet of 11" x 17" paper for a legal sized envelope ($4^1/_8$" x $9^1/_2$"). Choose any acid-free, light- to medium-weight

paper. You may want to use the same paper that you used to cover your boards, or use your endpapers or any plain paper that goes well with your layout.

Glue or paste
 Archival quality glue or paste. A glue stick is quite handy for making envelopes.
Paintbrush (to apply the glue if you are not using a glue stick)
Pencil
Ruler
Heavy weight, such as a book, to press the envelope as it dries
Wax paper

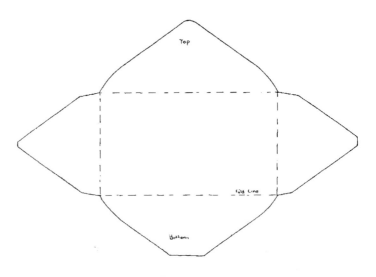

Figure 10-1

METHOD

1. Begin by copying the template provided (Figure 10-1) and drawing it out to the right size. You can also enlarge the template on a photocopier to the desired size.

2. Copy the pattern onto your sheet of paper and cut it out.

3. Using a ruler, bend the edges to create the pocket.

4. Glue the sides to the bottom of the envelope, leaving the top free.

5. Wrap the envelope in wax paper and let it dry under a heavy book or other weight.

HINTS AND TIPS

To add interest to your envelope, glue a piece of contrasting paper to the flap.

FIGURE 10-2

Another envelope option for a scrapbook is to make an envelope out of an entire page using an extra sheet of paper. Cut the paper so that when its edges are folded (Figure 10-2), it is the same width and half the length of the scrapbook page. Glue it onto the bottom and sides of the page so it forms a pocket. You can divide the pocket using ribbon or thread if desired (Figure 10-3).

You can glue your envelope inside the front cover of your scrapbook or on any page throughout. People love to open letters, and the act of removing a piece of paper from an envelope will make looking through your scrapbook even more enjoyable.

FIGURE 10-3

Plastic sheet protectors and even slide protectors can look great in a scrapbook, with a little creativity. Use full- and half-sheet protectors to store wonderful postcards and other two-sided memorabilia. Use plastic slide protectors to hold little treasures such as beads, bits of jewelry, pieces of fabric, and shells. To give them a more earthy look, plastic sheet protectors can be sewn up with natural-looking thread. They can be inserted in a binder with heavy paper as a contrast or in a book all their own to make an object-oriented scrapbook.

ANTIQUING PAPER

If you want to add interest to your scrapbook pages, consider antiquing your paper. Homemade "old" paper is less expensive and often just as attractive as handmade paper from a store.

Most people remember dragging a wet tea bag over white paper to give it a stained and aged quality. That is still an effective technique. To tea stain paper, crumple cardstock or some other heavy paper, smooth it out and repeat a few times. Then smooth it again and take a wet (but not dripping) teabag and rub it over the paper on both sides. Let little darker spots form to mimic the marks on a very old piece of paper. This is the simplest way to give paper an antique feel.

Another option is to wet the paper, then crumple it, straighten it out, and finally paint it with a light wash of watercolor paint. Dry it flat and then iron it or you can iron it while it is still damp to preserve some of the wrinkling. For an added touch, tear the edges to give it a truly handmade look.

A Personal Postscript

There's no one "right" way to make a scrapbook. The scrapbooks I saw while doing research for this book ranged from newsprint journals and children's scribblers to three-ring binders with plastic sleeves, to elegant archival quality albums and beautiful handmade books. Layouts varied from classic clutter to elaborate and artistic arrangement of the artifacts. Each scrapbook was idiosyncratic, a reflection of what the owner found important, precious, amusing, or inspiring.

What was common to all was the sense of pride and ownership on the part of the creator, the feeling of having made something meaningful and the sense of connection with the scrapbook and the stories it contained. For some, the scrapbook was a lasting legacy of inestimable value and an act of love.

I met so many wonderful people in the course of writing this book. When the youngest, four-year-old Duncan Clelland, brought his scrapbook over to me, he was anxious to show me every page. "I'll show you another page that's really good. Look!" And the eldest, ninety-one-year-old Evelyn Horton, began her most recent letter with the words, "I've just finished another scrapbook and started a new one. No end to the possibilities!"

No end to the possibilities, indeed.

Resources

The following list is not intended to be comprehensive. Rather it is a small selection of the sources we found most useful in putting this book together.

ARCHIVAL SUPPLIES

Brodart Library Supplies and Furnishings
109 Roy Boulevard
Brantford, ONT. N3R 7K1
phone 800-265-8470
fax 800-363-0483
Internet www.brodart.com
Canadian Library Supplier

Century Photo Products and Accessories
205 S. Puente Street
PO Box 2393
Brea, California 92822-2393
phone 800-767-0777
fax 800-786-7939

BOOKS

Bookbinding: A Manual of Techniques. Pamela Richmond. Crowood Press, 1989.

Cover to Cover: Creative Techniques for Making Beautiful Books, Journals & Albums. Shereen Lapantz. Lark Books, 1995.

This is an excellent book for aspiring bookmakers. It is filled with wonderful photographs and excellent instructions for a wide variety of imaginative bookmaking projects.

Decorative Boxes: To Create, Give and Keep. Juliet Bawden. North Light Books, 1993.

The Graphic Design Cookbook: Mix and Match Recipes for Faster, Better Layouts. Leonard Koren and R. Wippo Meckler. Chronicle Books, San Francisco, 1989.

Moments to Remember: The Art of Creating Scrapbook Memories. Jo Packham. Andrews McMeel Publishing, 1998.

Non-Adhesive Binding: Books Without Paste or Glue. Volume 1, Book Number 128. Keith A. Smith. Keith, 1994.

Practical Craft Projects. Acropolis Books, 1993.

Self Preservation: A Complete Guide to Keeping Your Memories Alive Through Journals, Photographs, Scrapbooks, Personal and Family Histories, Genealogical Records, Heirlooms, and Electronic Media. Anita Young Hallman. Deseret Book Company, 1997.

This is a very comprehesive guide to preserving scrapbooks and other materials. If you want to know more about creating archival quality albums, this book is a must-have.

Magazines and Websites

www.bookarts.com

This website is devoted to all the various bookarts, including papermaking and binding. It is well worth checking out.

www.creatingkeepsakes.com

This is a website for scrapbookers. It is an extension of the magazine by the same name. (Creating Keepsakes Magazine.)

www.gracefulbee.com

This is a website for scrapbookers to exchange advice and talk about their favorite pastime: creating scrapbooks.

Memory Makers: The Original Magazine of Creative Ideas for Photo Albums. P.O. Box 1929 Broomfield CO 80038-1929. (Magazine)

Index

0 64810 30163 4